D0688939

Ansel Adams: Classic Images

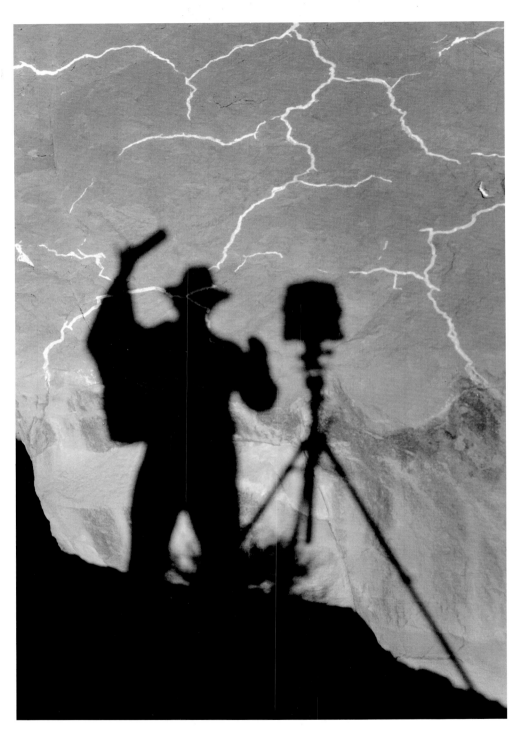

Self Portrait, Monument Valley, Utah, 1958

Ansel Adams: Classic Images

James Alinder

John Szarkowski

A New York Graphic Society Book

LITTLE, BROWN AND COMPANY · BOSTON

Copyright ©1985 by the Trustees of the Ansel Adams Publishing Rights Trust
"Introduction" copyright ©1986 by John Szarkowski
"Ansel Adams, American Artist" copyright ©1985 by James Alinder
"A Chronology" copyright ©1984, 1986 by James Alinder

All rights reserved. No part of this book may be reproduced in any form
or by any electronic or mechanical means, including information storage and
retrieval systems, without permission in writing from the publisher,
except by a reviewer who may quote brief passages in a review.

Second printing, 1986. This book was originally published in 1985
in slightly different form as the paperback catalogue for the National Gallery
of Art exhibition.

Library of Congress Cataloging-in-Publication Data

Alinder, James.
 Ansel Adams: classic images.

 Based on a catalog of an exhibition held at the
National Gallery of Art, Washington, D.C., Oct. 6,
1985–Jan. 12, 1986.
 1. Adams, Ansel, 1902–1984. 2. Photography,
Artistic—Exhibitions. I. Szarkowski, John.
II. Title.
TR647.A43 1985b 779.092′4 86-12487
ISBN 0-8212-1629-5

New York Graphic Society Books are published by Little, Brown and Company (Inc.).
Published simultaneously in Canada by Little, Brown & Company (Canada) Limited.

Printed in the United States of America

Introduction

The love that Americans poured out for the work and person of Ansel Adams during his old age, and that they have continued to express with undiminished enthusiasm since his death, is an extraordinary phenomenon, perhaps even one unparalleled in our country's response to a visual artist.

It is reasonable to regard the extraordinary with a degree of skepticism, and to look for the invisible wires or mirrors by which the trick was turned, or (on a more sophisticated level) to seek the confluence of anonymous cultural forces that might pick up the bark of an individual artist and carry it and him to fame and esteem. Adams was indeed in his latter years the right man in the right place. For the first time a substantial public had been educated to appreciate what he had done in his youth and middle age; his work as a conservationist was finally in tune with the intuitions of a substantial minority of his countrymen; the machinery that could intermediate between an independent photographer and his potential public—museums and galleries dedicated to the importance of the art of photography, skilled printers who could transpose a fine photograph into ink on paper, and imaginative publishers—was finally in place. Without these supporting structures Adams would not, I suppose, have become a hero to his countrymen, even though no less an artist.

Still, these structures were available to other photographers of exceptional achievement, some of whom also served the causes of conservation and ecological intelligence, and although some of these have been well served by the new circumstances, none has been granted the affection and trust of so broad a spectrum of his fellows as Adams.

I have in the past attempted to explain the nature of Adams' achievement in terms that could be encompassed within the broad thrust of photography's history:

"One might say that the great landscape photographers of the nineteenth century approached the natural world as if it were a collection of permanent and immutable facts, which might be objectively recorded and catalogued, given adequate time. Ansel Adams discovered that the natural world is infinitely varied in aspect, constantly potential, evanescent; that its grand vistas and its

microcosms are never twice the same; that the landscape is not only a place but an event.

"Trained as a musician, Adams understood the richness of variation that could be unfolded from a simple theme. As a young mountaineer in Yosemite, he learned from intimate experience and faithful attention the rhythms, structures and special effects of that delicately flamboyant place. In order to describe exactly his perceptions of the landscape, he had to develop a technique of extraordinary suppleness and precision, capable of evoking the specific quality of a given moment in the natural history of the world."

These observations still seem to me just and useful, but they do not seem adequate to explain the special esteem in which he came to be held by those countless many who could not have known, in rational, critical terms, how good an artist he was, but who sensed that he believed in something that they believed in: not the high sentiment of conservation, or the science of ecology, or the art of photography, but the deeply romantic idea that the great vistas and microcosmic details of the wilderness could be seen as metaphor for freedom and heroic aspiration. Adams' photographs seem to demonstrate that our world is what we would wish it was—a place with room in it for fresh beginnings. During Adams' lifetime it became progressively difficult to hold faith in this idea, and as he advanced toward old age the open, precise, lyric style of his youth gave way to one that was declamatory and epic.

In terms of the central ambitions of modern photography this change did not seem an advance, but in terms of the requirements of Adams' own intuitions it was necessary, and he was faithful to those intuitions. We can now be grateful that he was, for he has left us both the classic Adams of his youth and the romantic, magniloquent Adams of the later years.

In historical terms, we might see Ansel Adams as a bridge that links two traditions. He was perhaps the last important artist to describe the vestigial remnants of the aboriginal landscape in the confident belief that his subject was a representative part of the real world, rather than a great outdoor museum. He was certainly among those who sketched the outlines of a new sense of the meaning of the natural landscape, an understanding based on the earth's intimate details, its unnoted cases, its ephemeral gestures.

It seems unlikely that we will see again an artist like Adams. Younger photographers of integrity will presumably form their view of the world on the basis of their own experience, and they will have seen Yosemite not as a surviving fragment of Eden, but as a recreational center. If this is the case, Adams' work is all the more to be cherished. For those who share his memory of a world that seemed not yet quite fully used, it is a precious souvenir. For the young and for the future, it will define something of great value from a former time, now lost, that must be retrieved and reformed in different terms.

John Szarkowski

Ansel Adams, American Artist

James Alinder

Even though Charles Hitchcock Adams had been raised to be a correct and proper California gentleman, he wanted his life to be centered around an intense relationship to nature—to live the Emersonian ideal.[1] Carlie was born to wealth; his family owned the prosperous Washington Mill Company, headquartered in San Francisco, and in the late 1880s, as a young adult with a comfortable financial future, he could look forward to a life close to nature.

Carlie was an enthusiastic student who enjoyed two years as a science major at the University of California at Berkeley until his father insisted he end his formal education and learn to cope with the serious difficulties that had begun to occur in the family lumber company. He was the youngest Adams sibling, and the only one available to attempt to return the mill to prosperity. His brother was a doctor with a successful practice, and his three married sisters simply were not considered.

While the business struggled, Carlie's personal life fared better. He had met a young lady from Carson City, Nevada, at a San Francisco event; romance blossomed and he married Olive Bray in 1896.[2] During Olive's pregnancy in the second year of the new century, Carlie began construction of a family home on his chosen site in the sand dunes on the western edge of San Francisco. The panoramic view that stirred his soul was framed by Land's End to the west, and to the east by the Golden Gate, the entrance to San Francisco Bay, with the Marin headlands providing the background. He finished the house in 1903; with its natural, rural setting, it would be the perfect place to raise Ansel, the son born to Olive and Carlie on February 20 of the previous year.

The location was idyllic, isolated from the bustle of the city; Ansel was nurtured by Lobos Creek, which ran adjacent to the house, and by Baker Beach at the bottom of the hill. From his bedroom on the second floor, the view extended past Point Bonita and well out to sea. The historic San Francisco earthquake of 1906 damaged the house and caused Ansel to break his nose. While his nose was never fixed, the rest of a devastated San Francisco repaired its damage and life continued. The burgeoning postquake city continued its expansion, and soon the isolated Adams home was part of a neighborhood, with paving and a street address—129 Twenty-fourth Avenue.

Carlie was not finished with disaster, however, and the ensuing year of 1907 was the most tragic of his life. His optimistic, romantic spirit was crushed by his father's death and by the total failure of their lumber company. Within a brief time, the Washington Mill Company was besieged by fire, and most of the firm's lumber transporting ships were lost.[3] With the family wealth evaporated, Carlie resolved to uphold the Adams honor; he spent much of the rest of his life working to repay the business debts he now assumed. To further complicate his life, Olive's father and her sister, Mary, both without means, came to live with them permanently.

Despite Carlie's inability to revive the company's prosperity, Ansel always thought his father to be the most marvelous person. Carlie instilled in his son his Emersonian values—his philosophy of humanism and a conviction that beliefs should be expressed through action. He taught Ansel responsibility to society and the importance of transmitting knowledge to the next generation. He accepted as norms both individualism and nonconformity. Carlie was not religious in the institutional sense, and the family did not attend church; rather, he subscribed to Emerson's precept that religion was found in nature and was best practiced in a more direct relationship to God.

Ansel was born in a decade of great change. During the first years of the 1900s, new products such as aluminum, chrome, and synthetics were discovered; new ideas in painting included cubism, and in photography, the Photo-Secession; in science the theory of relativity, the quantum theory, and the structure of sub-atomic particles emerged. Carlie continued to be fascinated with science and began to take a special interest in astronomy.[4]

As for Ansel's education, even though Carlie believed with Emerson in the superiority of learning from life experiences, school was mandatory. But while he was an enormously curious and gifted child, Ansel was also hyperactive; he simply did not fit into the regimentation of the school life that began for him in 1908. His inability to adapt to its rigid structures led to his enrollment in a succession of schools in an attempt to find an appropriate match of student to institution. After several years of persistent, though unsuccessful search, Ansel's father had him tutored privately, with improved results.

Frustrated, yet understanding his son's need for a flexible structure, Carlie proposed an educational setting in 1915 that would still be thought innovative today. Ansel's classroom was to be the great fair that was being held in San Francisco to celebrate the opening of the Panama Canal. The thirteen-year-old student went to the Panama-Pacific International Exposition nearly every day for the year of its run. Carlie dropped his son off on his way to work, and whenever possible he left the office early so they could spend the afternoon touring the displays together.

Ansel studied each exhibit, and it is possible that those of photography and painting influenced his future as a visual artist. In the pictorial photography exhibition, Ansel saw the medium taken seriously and displayed as a fine art. The exhibit even included three prints by the young Southern California photographer Edward Weston. There were also several exhibits of contemporary painting and sculpture. Among the foreign contributions were works by Cézanne, Gauguin, Monet, van Gogh, Kokoschka, Munch, and the Italian futurists, but none by the French avant-garde. The cubist visions of Picasso and Braque were not displayed in San Francisco until a post-exposition show held the next year.

This educational experiment, supplemented with private tutors, was clearly a success; but the value of an alternative approach to his education became even more apparent with Ansel's increasing interest in the piano. An old upright had stood unused in the parlor of the Adams home for years, but in 1914, perhaps merely out of curiosity, Ansel gave it a serious try. With the kind of success that defines a prodigy, he taught himself the instrument. Carlie saw this newly discovered aptitude as a blessing and set about to find a piano teacher. During the next three years, Marie Butler taught Ansel; then he moved on to piano studies with Frederick Zech and, finally, with Benjamin Moore in 1925.

In later life, Ansel came to feel that the principal lasting effect of his study of the piano was the discipline it engendered. Applying himself seriously to problems in music, he discovered the nature of perfection and learned that constant practice is necessary to master a craft—exactitude can be attained only through relentless repetition. As a pianist, he honed his natural gifts to brilliant peaks of performance. There was certainly no doubt in his parents' minds that as a concert pianist Ansel would make them proud.

Two events in 1916—an introduction to photography and a family vacation in Yosemite—affected Ansel deeply and took control over his future, eventually turning him away from a career in music. The two occurred almost simultaneously; he took his first camera, a Kodak #1 Box Brownie, along on the family vacation to Yosemite that June. He was thrilled by the valley and recorded his reactions to the beauty that surrounded him. The early photographs show an innate visual sense that had no precedent in his family. Ansel was to return to Yosemite every year of his life. Photography was to become his life force.

Together, maturity and the study of the piano gave Ansel the discipline to concentrate in school. He returned to the classroom, receiving his grammar school diploma in 1917 from the Mrs. Kate M. Wilkins Private School. Ansel's formal education then ended; however, he continued to develop his primary interests of music and photography. While he had taught himself the basics of photography quickly, he picked up further experience, and pocket change, working that summer and the next at Frank Dittman's photo-finishing business in San Francisco. Compared to the elegant discipline of practicing musical scales on the piano, the endless production of quickly processed snapshots for Dittman's customers brought him no satisfaction. His developing feeling for quality was being offended. But soon Ansel learned what an art photograph of the day should look like—at the other aesthetic extreme from snapshots—from his neighbor, W. E. Dassonville, an exhibiting pictorialist photographer and the manufacturer of a beautiful photography printing paper for artists.

For Ansel, the 1920s and 1930s were a period of intense relationships, of a developing philosophy of life, music, photography, and the environment. The groundwork was laid for the contributions he would make—as an artist and as a citizen—throughout his life, and any accurate understanding of his complex character requires a close examination of those early relationships.

Beginning in 1919, Ansel worked during the summers in Yosemite as the custodian of the Sierra Club's headquarters. Since at the time the piano was of greater vocational importance to him than photography, he needed to find an instrument on which to practice. He located one at Best's

Studio, a Yosemite Valley concession selling paintings, photographs, books, and souvenirs. There he also found Virginia Best, an enthusiastic student of vocal music. Love bloomed almost immediately, though marriage would not take place for seven years.

The spiritual importance of the mountains to Ansel's evolving understanding of his photography, his environmental ethic, and his personality cannot be overstated. In the early 1920s, he began to make regular excursions into the high country of the Sierra Nevada surrounding Yosemite Valley, often traveling with Francis Holman, an ornithologist who taught and encouraged him. Uncle Frank, as Ansel called him, knew the Sierra as well as any man and passed on his respect for both land and animals. Ansel found a vast and uninhibited romance in wandering through unfenced country—and at times felt that this wilderness had never been traversed by man. The sense of mystery and majesty of the Sierra challenged his intellect, and the mountains also became subjects for his camera. Ansel photographed the Sierra incessantly and began publishing articles and photographs related to his treks in the *Sierra Club Bulletin*.

He also became a leader of the annual group expeditions sponsored by the Sierra Club. Many of the two hundred participants on these month-long outings were college professors and their wives from Stanford or Berkeley, who considered the trips a perfect summer vacation. In this company, the talks around the campfire each evening tended toward the intellectual and deepened the resources of Ansel's inquiring mind.

In order to develop his art beyond the advanced amateur level, Ansel experimented with the techniques then popular among pictorial photographers, proceeding from soft-focus negatives to bromoil prints. The prevailing taste prescribed that a photograph should look like a charcoal drawing in order to have the cachet of art. Ansel mastered these popular techniques, but before long abandoned them for a more direct photographic style that had the clarity of the mountains themselves. He dropped the pictorialist techniques not out of ignorance, but as a consequence of a conscious artistic decision. He now required that his prints be optically accurate, that they vividly depict and emotionally reflect his response to the scene. One of the few photographs from the soft-focus period that he printed and exhibited in later life is *Lodgepole Pines* (pl. 1).

Ansel searched for personal solutions to the age-old quest of the artist: to develop a concept that is his alone. While still a teenager, he had determined that light itself was the most important ingredient in the mix that made a fine photograph. He quickly found direct sunlight beaming at the subject to be boring; for his photographs, the light had to be special, revealing, important. He discovered that the most productive times to make photographs were early in the morning or late in the afternoon or in inclement weather.[5] He sought the definitive light, and he found it with a regularity that reflects his genius.

The principal subject matter of Ansel's photographs, the unspoiled natural world, was never in question.[6] Yosemite and the Sierra were his first locations, but the boundaries of Adams Territory soon extended into the Southwest, throughout California, and north to Alaska. While the photograph was a re-presentation of a reality already in existence, Ansel did not see it as a record of what was in front of his camera. Through careful and explicit arrangement he could negotiate formal linkages. He chose the proper lens in order to secure the best spatial relationship—neutral,

exaggerated, or compressed—as well as the angle of view. He selected the film for its particular spectral range and a filter for the best transmission of tones. And he carefully considered the edges of the view camera's ground-glass viewing screen so as to eliminate anything extraneous from the image. Ansel perfected the structuring of a rational visual order out of nature. He generalized the landscape to a broader truth; its form could reveal meaning in life through an insistent passion for beauty.

Coming out of a New England Puritan tradition—the Adams family emigrated from Northern Ireland to New England in the early 1700s—Ansel's intellectual development was consistent with middle-class American values of thrift, scientific curiosity, initiative, and industriousness. One person who had a considerable influence in broadening his philosophical base was Cedric Wright, the son of his father's attorney. Their deep friendship began in the fall of 1923. Cedric, a violinist who was a decade older than Ansel, had been fully involved in carving out his own philosophy of life. He shared his understanding with Ansel and introduced the younger musician to the ideas of Walt Whitman, Elbert Hubbard, and Edward Carpenter. To his Emersonian training, which gave man a sense of meaning and a place in the universe, Ansel added Whitman's love of America as a land of democratic ideals, with faith in the common good as central to spiritual growth. While Ansel and Cedric found great truth in both Emerson and Whitman, Hubbard was most important to Cedric: "Life without industry is guilt, industry without art is brutality."[7]

For Ansel the words of Edward Carpenter resounded his own beliefs. He considered Carpenter, whose values and verse structure acknowledged a debt to Whitman, to be the more poetic. *Towards Democracy* was his favorite of Carpenter's works, and he took the volume on the Sierra Club summer outings. He read and reread the poetry, memorized passages, and strongly recommended it to Virginia as a book that would expand her horizons. This selection from the poem "After Civilization" gives the flavor of Carpenter's meter and message.

In the first soft winds of spring, while snow yet lay on the ground—
Forth from the city into the great woods wandering,
Into the great silent white woods where they waited in their beauty and majesty
For man their companion to come:
There, in vision, out of the wreck of cities and civilizations . . .
I saw a new life, a new society, arise.
Man I saw arising once more to dwell with Nature.[8]

Another book by Carpenter in Ansel's library was *Angel's Wings,* subtitled *Essays on Art and Its Relation to Life.* A few quotations from it give a feeling for ideas that would become clearly visible in Ansel's personal aesthetic:

A work of art has to stand. It has to stand time, weather, beetles, and most of all the silent multitude of men's thoughts, emotions, experiences, perpetually invisibly gnawing at it, if anywhere they may find a weak spot. The greatest work is that which attracts most, and yet longest resists the corrosion of the thoughts which it attracts.[9]

Never again will Art attain to its largest and best expressions, till daily life itself once more is penetrated with beauty, and with the spirit of dedication—each part to the service of the Whole.[10]

It seems to me that the only way in which an artist can make his work durable and great is by seeking to arrive at the most direct expression of something actually felt by himself as a part of his own, and so part of all human experience. He must go to the root of all Art, namely the conveyance of an emotion or impression with the utmost force and directness from himself to another person.[11]

Both Ansel and Cedric sought a life dedicated to beauty in all its aspects, from music to photography to the mountains themselves. The daily concerns of each at the time were penetrated with beauty, and they pushed that concept to their limits. In time Ansel found an accessible photographic style—his subject matter had a universal appeal, his ideas were open and pure, and his resultant pictures had the formal elegance to stand time. Carpenter's goal of direct expression matched Ansel's emerging feeling that the best way to convey emotion with a photograph was through a straightforward approach.

Cedric Wright's influence on Ansel extended beyond their philosophical discussions. It was at a party in 1926 at Cedric's Berkeley home that Ansel met Albert Bender, a supporter of the arts who introduced him to the intelligentsia of the Bay Area. Bender became Ansel's patron, sponsoring his first portfolio, *Parmelian Prints of the High Sierras.*[12]

When Ansel was making the last photographs for this portfolio in the early months of 1927, he decided he wanted to include one of Half Dome. He climbed to a location that he felt would give an unparalleled view of Yosemite Valley's most spectacular earth gesture. He arrived there while the massive granite block was in full shade and waited for the light to be right. When the towering facade was illuminated, he reasoned through all the steps he felt necessary to create a photograph, from the strong feeling he was having toward the subject to the exposure he was about to make and through the processing of the negative to the making of the print. He knew enough about the film's sensitivity to light to realize that even with the yellow filter he had placed over the lens, the sky would come out a middle gray—but the emotional response he was having to the scene demanded that the sky should be black. So he changed to a red filter, which caused the emulsion's response to the blue sky to create a density on the negative that printed as black on the paper. The result was that the photograph Ansel made that day, *Monolith, the Face of Half Dome* (pl. 2) is optically accurate, but intensified in its tonal values.

Ansel considered this achievement a breakthrough, his first intellectually determined photograph. The term he appropriated was *visualization*—the ability to reason out before the exposure how the final print will look and to control the end result by taking action before the exposure is actually made. The concept of visualization is one of Ansel's major contributions, but one that is available only to photographers who have achieved the relatively high order of technical command necessary to understand and control the possibilities inherent in the materials of the medium. For Ansel this first visualization was a synthesis of his values; inner expression dominates reality, ideas dominate facts, the print dominates the subject. Verisimilitude is abandoned because the print itself is no longer the subject, but rather the expressive result of the artist's ideas.

Ansel's love of finely printed books and his subsequent ability to determine the quality in reproductions of photographs developed through his association with the Roxburghe Club. Albert Bender was an original member of the club, which was organized in 1927 to serve as a meeting ground for the fine printers of the San Francisco Bay Area and their followers. Bender brought Ansel into the club in 1928, and the young artist soon became friends with Robert and Edwin Grabhorn, of the renowned Grabhorn Press, and the Bentleys, who owned the Archetype Press of Berkeley. In later years, the Roxburghers sometimes met at Ansel's home. The level of taste and the concern for quality of these craftsmen became the standard that Ansel championed. For his books, he insisted on a level of photographic reproduction that was considerably more exacting than that thought possible at the time. His initial three books, unique and exquisite in their own ways, came directly from this tradition of fine printing. In the first and the most extreme example, *Taos Pueblo*, each picture in the book was not a reproduction, but an original photograph made in his darkroom, printed on sheets of book paper that had been hand coated with photographic emulsion. The text, by Mary Austin, was printed on the same paper by the Grabhorns and gathered with the photographs to make an exquisite edition of 108 copies published in 1930.

For the second book, *Making a Photograph* (1935), his first technical volume, the reproductions were letterpress printed separately on high-gloss paper and hand tipped onto each page. His intention was to give the viewer a close approximation of the actual values and aesthetic import of a fine print. These reproductions are often mistaken for original prints. The Bentleys' Archetype Press published the third book, *Sierra Nevada: The John Muir Trail*, in 1938. This handsome volume is the epitome of beautiful printing; the varnished plates again were hand tipped onto the oversize pages. Ansel was to publish more than thirty other titles during his lifetime. While the demand for his books came to require pressruns much larger than were possible with the early "fine editions," the quality of printing of even the largest editions of the 1970s and 1980s is extraordinarily good.

It had been Ansel's intention to delay marriage until he was self-sufficient, successful in a career, and able to afford a family life. He had made, and later broken, his engagement to Virginia; thus their relationship was in an uncertain phase when he went to see her in Yosemite for New Year's of 1928. Within hours he decided to offer himself again, without even having the security of knowing in which art—photography or music—he would make his career. Virginia accepted, and the ceremony was held three days later.

After two years of marriage, Ansel and Virginia built a house adjoining that of his parents, in the space that had been the family garden. His darkroom remained in his parents' basement. Chiseled into the fireplace mantel of Ansel and Virginia's new home, which became an important gathering place for anyone interested in the arts, was the title of one of Edward Carpenter's poems, "O Joy Divine of Friends."

Ansel was fun to be with and always had a new joke or story to share. Even though he was a compulsive worker who considered a sixteen-hour workday routine, he loved parties and often gave life to them. In the early decades, when his piano proficiency was still of a professional level, he would add to the conviviality by playing a classical concert. This musical ability provided him

entrance into social circles that might have been much less open to him had he been known only for his photography. Mabel Dodge Luhan, the arts hostess of Taos, New Mexico, for example, extended an open invitation to her estate, where the assemblage on any given night might include such notable figures as John Marin, Georgia O'Keeffe, or Robinson Jeffers. After dinner Ansel would be asked to play, and he would routinely dazzle the audience.

During a photographic trip to Taos in 1930, Ansel arrived at Mabel Dodge Luhan's only to find the artists' bungalows completely full. Consequently, the photographer Paul Strand, visiting from New York, offered him a bedroom in his cottage. But what proved more significant than his hospitality was Paul's sharing of a group of his recent negatives. Ansel's reaction was profound. Only someone completely conversant with the art could be so strongly affected by looking at the raw material from which the artist's prints were to be made. Strand also talked about his total commitment to photography as a fine art, about his friend Alfred Stieglitz, and about the artistic ferment in New York. Here was an intelligent, humanistic, and apparently successful individual who was also a creative photographer. This intimate contact with an artist and his negatives culminated in Ansel's decision to devote his creative life to photography.

With a career finally determined, Ansel opened his studio in his San Francisco home and plunged into a variety of photography-related activities. In 1931 he began writing photography reviews for a local magazine, *The Fortnightly*. One of his early reviews was of an exhibition by Edward Weston, whom he had met several years earlier at Albert Bender's. Weston wrote Ansel thanking him for his perceptive review, and the next year, a long-term friendship between the two artists began. A number of other photographers in the greater San Francisco Bay Area were fully dedicated to the medium as an art as well. In 1932 the like-minded photographers Imogen Cunningham, Henry Swift, Sonya Noskowiak, John Paul Edwards, Weston, and Ansel gathered at the Oakland residence of Willard Van Dyke. These seven, disgusted with the dominance of pictorialism in fine art photography, decided to join together to promote what they called "straight" or "pure" photography. They adopted the name Group $f/64$, the number referring to the smallest aperture setting common on view camera lenses—one that gave great depth of field and hence afforded maximum sharpness throughout a photograph.

Even though it was a loosely knit conclave that met only a few times and held just three exhibitions, Group $f/64$ became a seminal influence on the history of photography. Its first and most significant showing was at San Francisco's de Young Memorial Museum in 1932, and the artists used the occasion to present a manifesto proclaiming their concept of photography as a new American art form. Their manifesto stated, in part:

> The Group will show no work at any time that does not conform to its standards of pure photography. Pure photography is defined as possessing no qualities of technique, composition or idea, derivative of any other art form. . . . The members of Group $f/64$ believe that photography, as an art form, must develop along lines defined by the actualities and limitations of the photographic medium. . . .

For Ansel, Group $f/64$ provided a unity of thought and style with distinct limits. It proposed methods that would produce images with the most distinctively photographic characteristics: the

use of a view camera, frequently with an 8x10-inch negative; the use of lenses giving extreme optical sharpness; prints with a full tonal range made in direct contact with the negative on a glossy paper. The more extreme of the $f/64$ adherents did not enlarge the negative because the process magnified the grain of the photographic emulsion and thus reduced the maximum detail.

As Ansel's visual ideas were reinforced by $f/64$ ideals, his work underwent change. While he already used a large-format view camera regularly, he now switched to smooth, glossy paper. His darkroom skills were so adroit that he could even produce enlargements that few could distinguish from contact prints. Close-up views such as *Rose and Driftwood* (pl. 7) were a convention among members of Group $f/64$; now Ansel transferred the same concept to the landscape in *Frozen Lake and Cliffs* (pl. 9). Without a defining horizon, the frame filled with fragmented granite shapes takes on a new sense of abstraction. Another image from the High Sierra with a similar visual tension and a minimal subject is *High Country Crags and Moon, Sunrise* (pl. 10). The existence of obvious natural beauty was not a precondition for Ansel's making a photograph; he frequently made great images such as these from subjects that might have been overlooked by a lesser artist.

At the same time he was developing this greater understanding of his creative work, Ansel began taking assignments as a commercial photographer. This was very common among artist/photographers of the time; his friends Strand and Weston both did commercial work to support their creative art. For Ansel his personal work was ineluctable; those assignments came from "within," as he put it. While he would give total concentration to commercial jobs, he considered them assignments from "without." There was a clear distinction between art and commerce.

While the prior decade of intense exploration with the camera and in the darkroom had made Ansel among the most capable of photographers, the commissions produced fresh demands, such as working with newly introduced color materials. Although he mastered color photography for his assignments, Ansel rarely used it in his creative work, feeling it lacked controls and could not communicate the depth of emotion that could be engendered in black and white. His corporate clients included *Fortune* and *Life* magazines and the Eastman Kodak Company, for whom he produced several coloramas—giant display transparencies that were exhibited in New York's Grand Central Station. He used many cameras, all sizes—35mm, 2¼ square, 4x5, 8x10, and even a 7x17-inch banquet camera—for the coloramas. This work provided an ongoing source of income, and he continued taking commercial assignments into the 1970s.

While Ansel gained friends who appreciated his work and won the admiration of many photographers who were peers, the power in art photography in the first half of the century rested with one man, Alfred Stieglitz. Encouraged and accompanied by Virginia, Ansel took the train to New York in 1933 to show Stieglitz his portfolio. A genuine interest and mutual respect followed, with Stieglitz offering Ansel an exhibition in 1936. This would be the first exhibition he had given to a photographer since Strand's showing in 1917. For Ansel that acceptance was of inestimable value, making him a part of Stieglitz's circle and giving him an enlarged perspective of art. He now belonged to the tradition in art photography, and he adopted Stieglitz's terminology of the "equivalent," expressing the idea that a creative photograph was the visual equivalent of what one saw and felt. Ansel even tried the role of gallery director and opened his own gallery in San Francisco for a year.

During these years, Ansel had continued his long-term involvement with the Sierra Club, and in 1934 he was elected to its Board of Directors. After learning the issues, he used this forum to speak about the nation's lack of concern for the land and its resources. He proved to be such an energetic and effective proselytizer that the club sent him to Washington, D.C., two years later. Using both his photographs and his voice, Ansel lobbied Congress with missionary zeal for the establishment of the Kings Canyon region of the Sierra Nevada as a national park. Throughout the rest of his life, he fought an unending series of battles—losing some, winning others—to preserve America for future generations.

Ansel and Virginia had two children, Michael and Anne, both born in the mid-1930s. With her father's death in the fall of 1936, Virginia inherited Best's Studio, and she and Ansel moved their family to Yosemite the next spring. Ansel now had increased accessibility to Yosemite for his photographs, as well as to the Yosemite Park and Curry Company—the major owner of park concessions and his largest commercial client. He maintained his studio and business contacts in San Francisco, a five-hour drive from the valley, causing a split family life that continued until Ansel and Virginia moved to Carmel together in 1962.

An association that began during the late 1930s was to be pivotal in Ansel's life—his contact with Beaumont and Nancy Newhall. They became fast friends, and the relationship gained in intensity over the next three decades. Ansel joined with Beaumont and David McAlpin as the prime instigators in the creation of a department of photography at the Museum of Modern Art in New York City. Nancy wrote the texts for many of Ansel's photographic books and became his first biographer.[13]

It was on a trip in 1940 along the coast between San Francisco and Carmel, made so that he could personally introduce the Newhalls to Edward Weston, that Ansel had one of his most innovative moments. *Surf Sequence* (pls. 26-30) is a series of five prints expressly made to be seen as a series, with quiet musical and poetic changes. With his 4x5 view camera aimed directly down at the restless, undulating waves, Ansel created a consecutive image relationship that was unprecedented, one that prefigured sequential concerns among creative photographers some thirty years later.

The 1940s were the most productive years of Ansel's career; his photographic style attained full development, and he made many of his classic images. His activities in support of photography as an art form also expanded. He increased his teaching and published accounts of the technique he codified, the Zone System. He also established academic departments for teaching photography and organized photography exhibitions. Two fellowships he received at the end of the period gave him more time for creative photography.

Of all Ansel's technically oriented ideas, the most fundamental, yet arcane, is the Zone System. Developed in 1941 as a system of simplified applied sensitometry, it divided the tonal scale into eleven zones, or steps, from black to white. Total black is zone zero, middle gray is zone five, and pure white is zone ten.[14] With this system, the photographer was given the means to assess the general contrast range of his subject and to determine what specific areas related to specific zones of tone in the final print. He could then expose the film and develop it to learned

standards that would provide the desired densities for the visualized image. Despite changes in modern film emulsions that make them less reactive, the Zone System still has application for serious photographers who desire the most refined technical results. Ansel's teaching interests were not purely technical, however. In the same breath that he spoke of the Zone System, he would comment that there was nothing worse than a sharp picture of a fuzzy concept and that technique for its own sake had no purpose, but acquired value only according to how it strengthened the photographer's ability to express his visual ideas.

Ansel's photographs from the early 1940s become expansive and heroic. Though he could not serve on active duty, he desperately wanted to be part of the war effort. He was able to find minor roles, such as teaching photography to army officers, but his most important contribution was in showing America something of what it was fighting for.[15] These classic images begin with *Moonrise* in 1941 (pl. 32), continue with *The Tetons and Snake River* in 1942 (pl. 35), *Clearing Winter Storm* (pl. 46), and *Winter Sunrise* (pl. 38) in 1944, and *Mount Williamson* (pl. 40) in 1945. In these epic vistas, photographs that captured the glory of the country, Ansel made visual equivalents to American values: a great democratic country, with wide, sweeping landscapes of grandeur and majesty. The subjects of these photographs are enhanced by visualization to portray a landscape that is beyond the limits of human experience. Yet because they are photographs, one accepts the print as true. They are not true to fact, but faithful to Ansel's reverential ideal of nature and of a pure, unspoiled America. In these photographs, the land in the West, and in California in particular, is expansive and optimistic. It promises a better life.

When Ansel made *Moonrise* (pl. 32), in the late afternoon of October 31, 1941, he immediately knew he possessed an important negative. He could not have guessed, of course, that it would become the best-known image in the art of photography. It was the first of his photographs to take on a life of its own, as masterpieces do. *Moonrise* is spiritual, redemptory of man and earth. It visualizes the basics of existence, ideas that are rural and in touch with the earth. The print is physically dominated by a black sky in an unusual use of space, but one essential to its spirit. The light on the crosses, critical to the image, disappeared as the sun set seconds after his exposure was made.

Clearing Winter Storm (pl. 46) is the most successful of dozens of photographs Ansel made from the same location over many years. Overlooking Yosemite Valley, the picture spot was called the "Best General View" by nineteenth-century photographers. This inspirational view, although somewhat changed when a new tunnel and road were built, has been photographed by millions of tourists, both amateurs and professionals, for more than a century. Many have fine and memorable shots based on the beauty of the scene alone. Ansel's great picture of this "best view" eluded him for years, but one winter day in 1944, just as a storm was ending, the sun brilliantly reappeared, and the clouds took on a form he had never before seen. In *Clearing Winter Storm*, Ansel captured that special earth event.

Disturbed by the treatment of loyal Japanese-American citizens during the war, Ansel was delighted to be asked if he was interested in documenting the internees living at the detention camp at Manzanar, on the east slope of the Sierra Nevada. He enthusiastically took up the project

and produced a group of photographs that show a magnificent people coping with an unfortunate situation. Published in 1944 as *Born Free and Equal*, with his photographs and text, the book is an artist's humanitarian statement about the effects of the overreaction created by blind prejudice. The text contains some of Ansel's most powerful writing and, combined with the images, documents the dignity and pride retained by those interned at Manzanar. Although Ansel was conversant with the photo essay form that had been pioneered by *Life* magazine, and could have used that more intimate style with a 35mm camera and available light, he chose instead to use the view camera. The resulting photographs make a clear and respectful statement. Yet this more detached and classic stance seems stilted by comparison with similar 35mm work of the time and is intellectually rather than physically involving. The values of the prints were important to Ansel; he was making art, and the fact of a documentary subject did not compromise his standards. During his visits to Manzanar, Ansel made two classic landscape photographs, the epiphanous *Mount Williamson* (pl. 40) and the haunting *Winter Sunrise* (pl. 38), both in the vicinity of the detention camp.

Ansel was a compulsive photographer, and the sheer number of important photographs he made has overshadowed other significant aspects of his career, such as his writing. The excellence of his technical books is recognized, and both his critical writing on photography—often undertaken in connection with exhibitions he organized—and his environmental writing are esteemed. He also wrote extraordinary letters, voluminously in the days before the telephone became the primary means of communication. By the late 1940s, Ansel's personal force was as much recognized as was his photography; he was a respected leader and spokesman both for photography as a fine art and for the environment. He was concerned, however, that his great range of activities would lessen his effectiveness as an artist, the role that was most significant to him.

Ansel's first two Guggenheim Foundation Fellowships, in 1946 and 1948, gave him the opportunity to spend substantial amounts of time photographing the national parks and monuments of America, and these travels included his first visits to Alaska and Hawaii.

The finest images from these years include *Dawn, Autumn, Great Smoky Mountain National Park* (pl. 39); *Vernal Fall, Oak Tree, Snowstorm* and *Tenaya Creek, Dogwood, Rain* (pls. 23, 45, 47) all from Yosemite Valley; as well as *Trailside* and *Mount McKinley and Wonder Lake* (pls. 53, 54) from Alaska. As a group, these photographs continue to celebrate America and to postulate graphically the importance of leaving land in its natural state, presumed in these cases to be protected by the government. By implication, nature is perfection, and the sublime beauty expressed in these national park photographs is in complete contrast to the state of the world outside. Visual artists make images, and Ansel created such images, perfect in their own terms, rather than records of what existed and might be lost. His inspiration to photograph nature came from within himself, and he maintained that he never intentionally made an environmental photograph; he routinely, however, allowed his creative works to be used on behalf of environmental concerns.

Two other images in the national park and monument series made during the 1940s, just as important as photographs although not epic in their imagery, are *Sand Bar, Rio Grande*, from Big Bend National Park (pl. 42) and *Sand Dunes, Sunrise*, from Death Valley National Monument (pl. 37). They are among Ansel's most exquisite images; both rely on formal arrangements and have in common a great curved line. In *Sand Dunes, Sunrise*, he used the sharp light at dawn to endow

the shape. In *Sand Bar, Rio Grande*, the form was created through contrasting tonal units, using reflected light off the river to make the brightest, most substantial tonal area. In both, a sense of abstraction and a very modern perception have made the moment; it is the seeing, not the subject, that is crucial. The photographer used form to order the chaos of the landscape and give it meaning, splendor, and coherence.

The great amount of energy Ansel spent photographing during and after the war years came to fruition in publications and exhibitions. The late 1940s saw the publication of the first two books of Ansel's basic technical series, *Camera and Lens* and *The Negative*; the release of *Portfolio I*, to be followed by six more portfolios over the next three decades; and the establishment of a close friendship with Dr. Edwin Land, who employed Ansel as a consultant to his newly formed Polaroid Corporation. His publishing continued in the 1950s with the production of a number of books—three in 1954 alone.

Two activities at this time centered around Yosemite. While he had taught photography workshops intermittently for many years, in 1955 he established the Ansel Adams Yosemite Workshop to provide an intense, short-term learning experience in creative photography. Over the years, Ansel educated and inspired thousands of hopeful photographers and encouraged them to develop both their personal vision and their technical expertise.

Ansel and Virginia had been troubled by the poor quality of souvenirs available to tourists in Yosemite; the curios sold there were frequently tasteless, inappropriate, or, ironically, stamped "Made in Hong Kong." To provide a high-quality, reasonably priced memento, Ansel began to produce a series of Yosemite Special Edition Prints. These unsigned 8x10-inch prints, made by his assistants and meeting his strict requirements, were sold only at Best's Studio. This concept of providing beautiful, inexpensive prints was consistent with Ansel's egalitarian beliefs. Public acceptance of the project was strong; thousand have been purchased over the past thirty years.

Ansel continued to photograph during the 1950s, although not with the frequency he had in the previous decade, his energies concentrated more upon commercial work, teaching, and writing. Two of his later photographs, with common and singular subject matter—trees—provide an interesting comparison. *Aspens, Northern New Mexico* (pl. 63) is an image Ansel improved greatly by using the Zone System, creating increased contrast of the dull, flat light actually falling on the subject. The contrast enhances the concinnity of the trees, with the forward-most tree appearing to lead a rhythmic procession through space. *Redwoods, Bull Creek Flat* (pl. 72) is dramatically different. Here the trees are portrayed as a flat plane; one row of massive, overpowering redwoods. Nature is again revered. No one could even consider walking through either group of trees; they may only be approached and enjoyed visually.

Ansel and Virginia began the 1960s by moving to a new house in Carmel Highlands, one built specifically to suit the photographer's life-style.[16] The main floor living area was dominated by the darkroom, workroom, office, and gallery, but it also contained a wonderful fireplace and a much-used living room area with broad views of the Pacific Ocean. When work ended, the well-stocked bar was opened, and a stream of visitors was received every day. Ansel delighted in using this time to look at student portfolios and visit with fellow photographers, environmentalists, and musicians, among others.

The darkroom was also busy. Because of an increased public interest in creative photography in general, and in Ansel's work in particular, most of the fine prints made during his career were produced in his Carmel darkroom. His printing values changed over the years. Ansel's early images were first printed with subtly soft tonal values; they later became more dramatic, generally darker, with more contrast. The darkroom was also a testing ground for new materials. Concerned with how long his photographs would last, he tested and refined archival processing techniques so that his fine prints could have a maximum life.[17]

Ansel made few important new photographs after moving to Carmel. Although his production of exhibitions, books, and portfolios continued unabated, the distractions from camera work in the field were many. His sphere of influence was now national in scope; presidents sought his advice, and he began to receive a series of important awards in recognition of his accomplishments in both photography and environmental concerns.

He continued to be part of significant activities that laid the foundation for the modern growth of creative photography, ranging from the founding of *Aperture* in 1952 to the creation in 1975 of the Center for Creative Photography at the University of Arizona, where his archive was established. In January of 1967, several friends—Beaumont and Nancy Newhall, Brett Weston, Cole Weston, and others—gathered at his Carmel Highlands home to discuss the formation of a group that would serve to promote photography as a fine art. The enterprise was named The Friends of Photography, and Ansel was its first president. During his tenure, The Friends grew to become the largest member-based creative photography organization in the world.

As the demand for his classic photographs began to accelerate in the mid-1970s, Ansel found himself constantly reprinting those past experiences, with little time to work on new projects. At the end of 1975, he stopped taking print orders, but it took him three years to make the more than three thousand prints already requested. By 1979 the increased desire for his prints, both in public auctions and through photography dealers, led to a dramatic expansion of interest in collecting photographs by individuals and institutions.[18]

In a further commitment to the future of creative photography, Ansel and Virginia passed on not only their knowledge, but also a good portion of their financial resources. Major donations included the endowment of a permanent curatorial fellowship at the Museum of Modern Art and the promised gift of their Carmel home and studio to The Friends of Photography.

By 1980 Ansel was at the pinnacle of his influence. He was the subject of numerous articles, including a *Time* cover story.[19] President Jimmy Carter presented him with America's highest civilian honor, the Presidential Medal of Freedom. His citation stated:

At one with the power of the American landscape, and renowned for the patient skill and timeless beauty of his work, photographer Ansel Adams has been visionary in his efforts to preserve this country's wild and scenic areas, both on film and on Earth. Drawn to the beauty of nature's monuments, he is regarded by environmentalists as a monument himself, and by photographers as a national institution. It is through his foresight and fortitude that so much of America has been saved for future Americans.

The artist had become a national hero, a respected champion of art and nature. This status had very little effect on his ego, however, except to encourage him to continue the fight for environmental protection. His views could now capture national headlines and sway the opinion of millions. He lobbied actively on a variety of environmental and political causes, and wrote letter after letter to the editors of local and national publications.

The appointment of James Watt as secretary of interior was for Ansel the single most unfortunate environmental decision of the century. He feared that through this one man the government could undo all the good that had been accomplished, and he fought Watt's policies vehemently. In his public protests and in his strong support of The Wilderness Society, he attempted to restore the balance of legislative progress on the side of the environment.

Two projects occupied much of Ansel's time as he entered the 1980s: the Museum Sets— groups of prints intended to enrich the collections of museums worldwide—and his autobiography. Setting down the experiences of a lifetime as rich and varied as Ansel's required an effort of large proportion. Now nearing eighty, but still open as he always had been to the challenges of new technologies, he purchased a computer to allow him to process the events of his life more efficiently.

In his last years, Ansel kept an active work schedule, with new projects beginning with a regularity that would exhaust a man half his age. But he had a history of heart trouble. He underwent a successful triple coronary bypass operation and aortic valve replacement in 1978 and was further aided by a pacemaker beginning in 1982. On Easter Sunday, April 22, 1984, Ansel's heart failed, and death came peacefully.

Ansel had become a symbol of the best of America, and an outpouring of love, reverence, and a sense of true loss was expressed by a wide cross section of the population. Major stories appeared on all television networks and on the front pages of newspapers nationwide. A celebration of his life was held in Carmel, and exhibitions in his memory were shown at a number of museums. He was remembered as a truly great American, a preeminent artist who left a legacy of indelible images. The California Wilderness Bill, passed by Congress later in the year, set aside more than one hundred thousand acres as the Ansel Adams Wilderness Area between Yosemite National Park and the John Muir Wilderness Area. A twelve-thousand-foot mountain in one of his favorite areas of Yosemite, a peak near the Lyell Fork of the Merced River that he had first climbed in 1921, has been officially named Mount Ansel Adams.

Some eighty years before, Carlie Adams had let his young son know that he was special; no limits were set on what he could achieve, and the significance and breadth of his accomplishments are astonishing. He was a great photographer and a leader in the environmental movement, an impressive musician, a writer of significance, an organizer of support groups, an effective teacher, an aesthetic theorist, a liaison between creative photography and the general public, a systematizer of photographic technique, a benefactor of photography, and a force that became a symbol of a life well spent. The material record of his artistic career—forty thousand negatives made, some ten thousand signed fine prints produced, more than five hundred exhibitions of his images presented, and more than a million copies of his books purchased—is unprecedented in photography.

Ansel's accomplishments were the product of a complicated personality, but his complexity was not outwardly apparent. He looked and dressed the part of a western mountain man. His beard and Stetson became trademarks—symbols of a great artist who believed in America as a chosen place. He could have an intellectual discussion on magnetic fusion technology one minute and relay a series of raucous jokes the next. When he believed in something his determination took on the quality of bulldog stubbornness, yet he listened thoughtfully to all sides of a question. He was really happy only when he was working. He had distinct and articulated values, particularly in his efforts to protect our environment; and what he professed came to be believed by increasing numbers of Americans. Ansel used his power intelligently and ethically.

Finally, no artist has been closer to nature. Securing his inspiration from the Sierra, from Yosemite, and from all of America's wild and scenic lands, he had little need to look elsewhere for ideas or subjects. His work created a world that is indestructible and eternal; it articulates a reality greater than us. Ansel continues to convince us of life's worth in the work he has passed on and in the afterimage of his unique spirit.

Notes

1. Ansel Adams' father was born in 1868, in San Francisco, California, the fifth child of William and Cassandra Adams. For these facts and other observations, I am indebted to Virginia Adams, who generously gave me the benefit of her remarkable memory and perceptions. Mary Alinder, my wife and the editor of Ansel's autobiography, has also shared with me her peerless research and considerable understanding of the artist. From 1978 until his death, I talked with Ansel almost every day; over these hundreds of hours, he became my best professional friend.

2. Olive Bray was born in Iowa in 1862 to Charles and Nan Bray and was raised in Carson City, Nevada.

3. While not authenticated, it has been reported in histories of the Adams family that six of their chain of lumber mills and twenty-seven of their ships were lost or destroyed in the decade before 1907, with no insurance coverage to soften the disasters.

4. Indicative of their mutual interest in science, Ansel's 1924 Christmas gift to his father was a copy of *Easy Lessons in Einstein*. Carlie became very active in the Astronomical Society of the Pacific and served as its secretary for the rest of his life.

5. The time or weather condition is often included in a photograph's title, for example, *Frozen Lake*; *Aspens, Dawn*; *Oak Tree, Snowstorm*; *Merced River, Winter*; *River, Cliffs, Autumn*; *Sand Dunes, Sunrise*; *Winter Sunrise*; *Dawn, Autumn*; *Autumn Storm*; *Clearing Storm, Sonoma*; *Cypress and Fog*; *Evening Clouds and Pool*; *Clearing Winter Storm*; and *Moonrise* (which, of course, is also a sunset).

6. Ansel made important photographs of many other subjects. His portraits, for example, were the subject of a monograph: see James Alinder, *Ansel Adams: Fifty Years of Portraits* (Carmel: The Friends of Photography, 1978).

7. Elbert Hubbard, *The Liberators* (Erie, New York: Roycrofters, 1919), unpaged prefatory matter.

8. Edward Carpenter, *Towards Democracy* (London: George Allen & Co., Ltd., 1912), pp. 260-61.

9. Edward Carpenter, *Angel's Wings*. 7th ed. (London: George Allen & Unwin Ltd., 1923), p. 38.

10. Ibid., p. 64.

11. Ibid., p. 97.

12. Ansel forever regretted the grammatical mistake in the portfolio's title: *Sierra* is already a plural.

13. Her biography *Ansel Adams: The Eloquent Light* (San Francisco: Sierra Club, 1963) covers the years 1902-38.

14. In his original codification, there were ten rather than eleven zones. For a full discussion of the Zone System, see Ansel Adams, *The Negative* (Boston: New York Graphic Society, 1981), pp. 47-97.

15. While this may not have been his explicit conscious intent, Ansel accepted this interpretation in retrospect. For the first proposal of this idea, see Mary Alinder, *Ansel Adams: The Eightieth Birthday Retrospective* (Monterey Peninsula Museum of Art, 1982), unpaged.

16. The house was located only a mile south of Edward Weston's home, the "palatial shack" on Wildcat Hill where Weston had lived for the last two decades of his life. Weston died four years before the Adamses moved to Carmel.

17. It is believed that the archival quality of his processing technique will give his prints an informational life as long as four thousand years.

18. Incredibly, the prints of a single artist—Ansel Adams—accounted for half of the total dollar value of photography sales during 1979. Two years later, a mural-size print of *Moonrise* sold for $71,500, the highest price then paid for a single photograph. Since Ansel was no longer making prints for sale, and those already made were in the hands of dealers or collectors, he received none of the financial benefit of the dramatic price rises, except indirectly in increased royalties through greater publication sales.

19. The *Time* cover story is dated September 3, 1979; his longest published interview is in the May 1983 issue of *Playboy*.

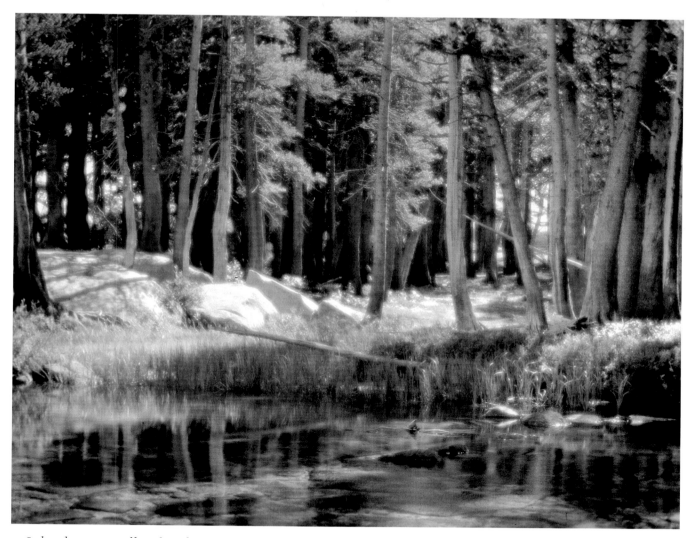

1. Lodgepole Pines, Lyell Fork of the Merced River, Yosemite National Park, California, 1921

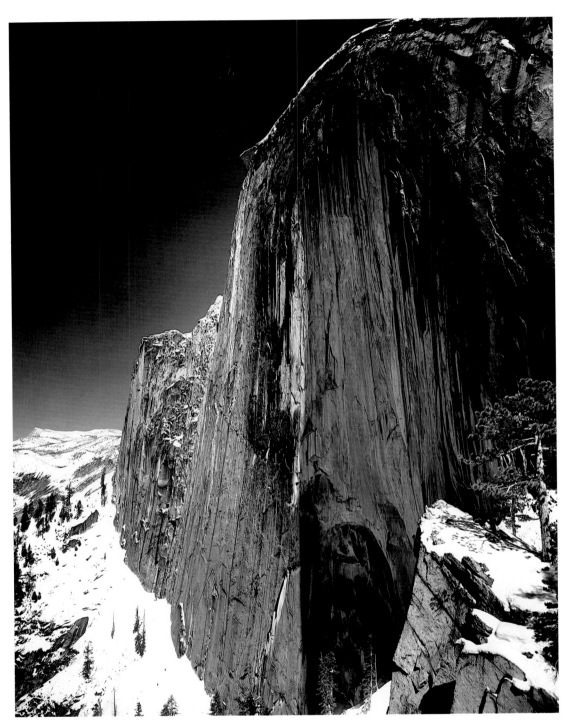

2. *Monolith, the Face of Half Dome, Yosemite National Park, California, 1927*

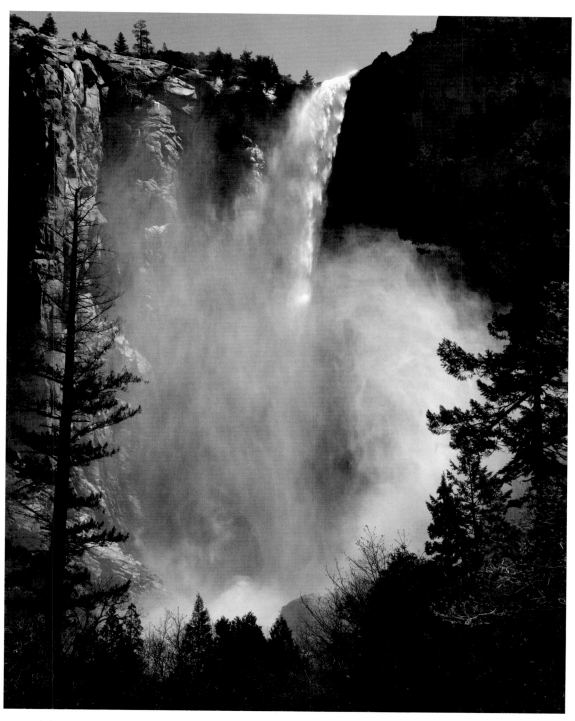

3. Bridal Veil Fall, Yosemite National Park, California, c. 1927

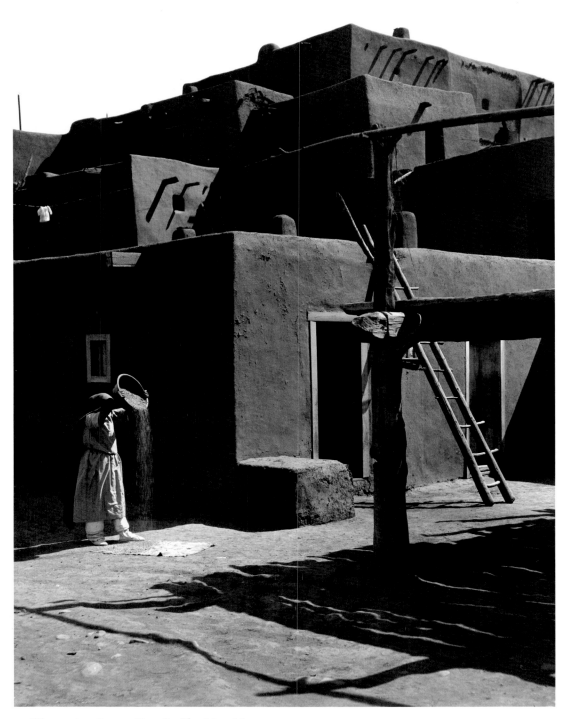

4. Winnowing Grain, Taos Pueblo, New Mexico, c. 1929

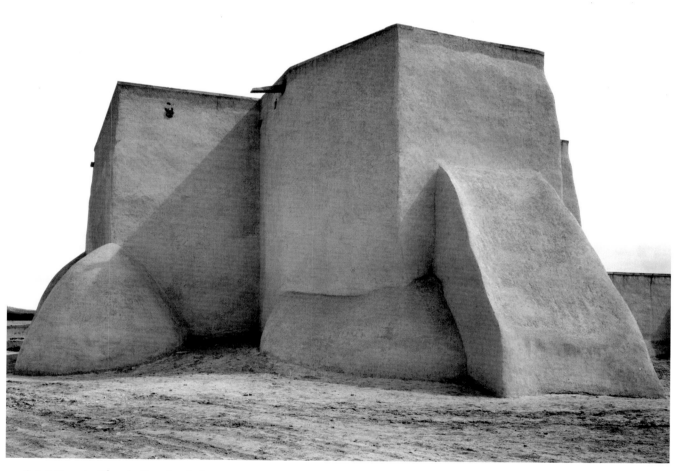

5. Saint Francis Church, Ranchos de Taos, New Mexico, c. 1929

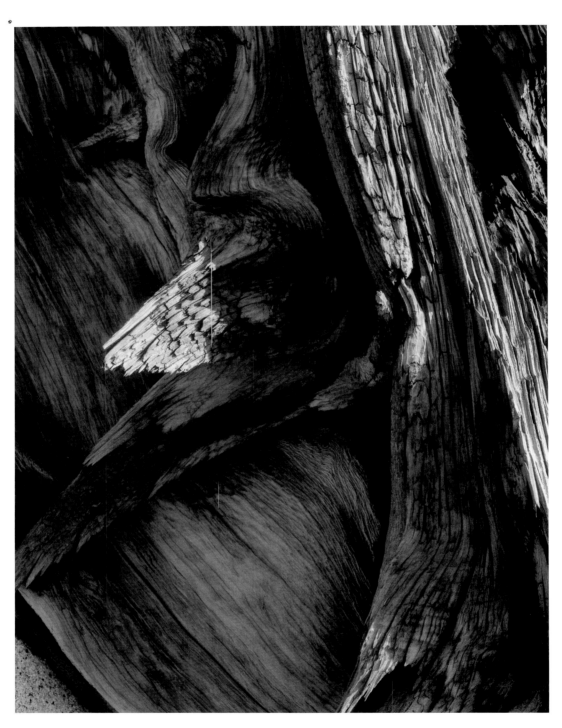

6. *Juniper Tree Detail, Sequoia National Park, California, c. 1927*

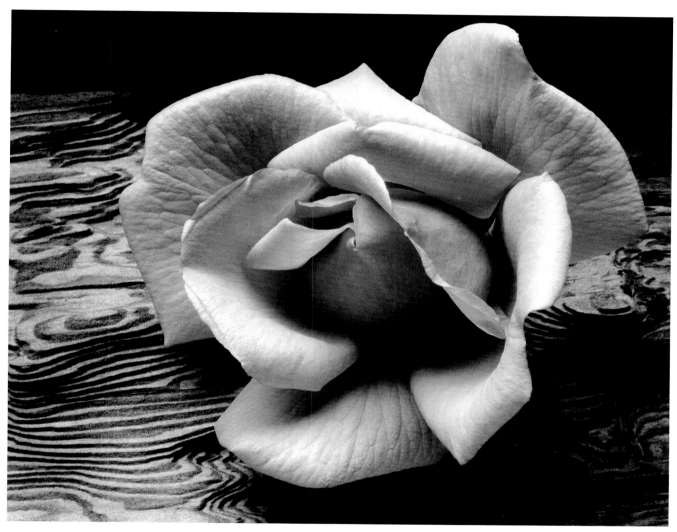

7. *Rose and Driftwood, San Francisco, California, c. 1932*

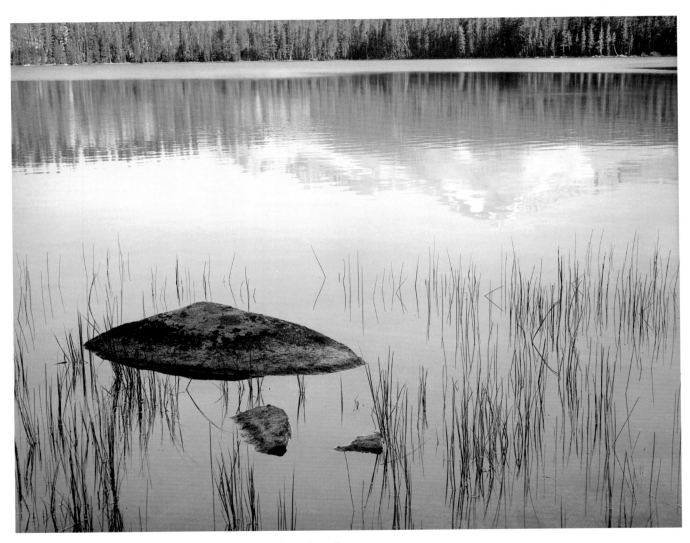

8. *Rock and Grass, Moraine Lake, Sequoia National Park, California, c. 1932*

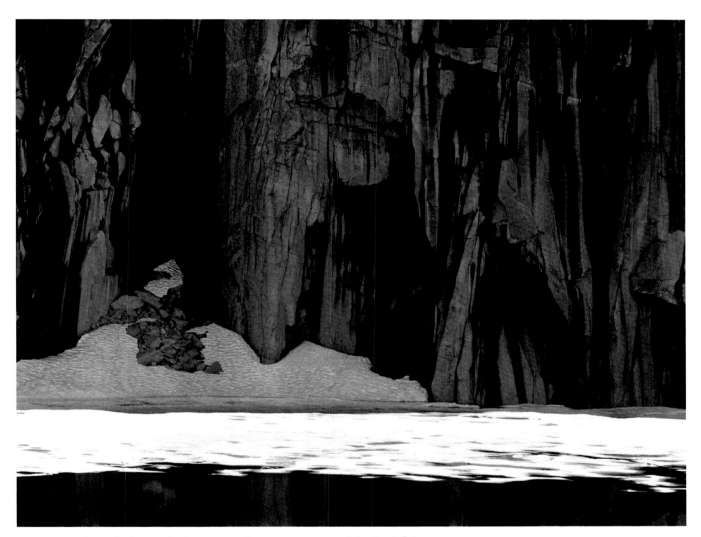

9. *Frozen Lake and Cliffs, The Sierra Nevada, Sequoia National Park, California, 1932*

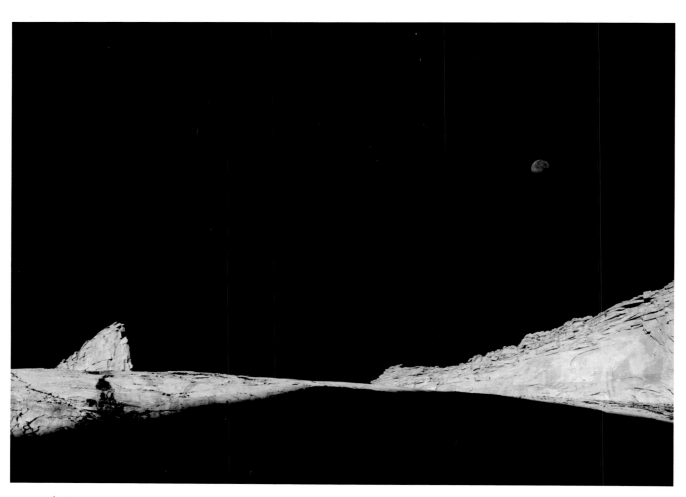

10. High Country Crags and Moon, Sunrise, Kings Canyon National Park, California, c. 1935

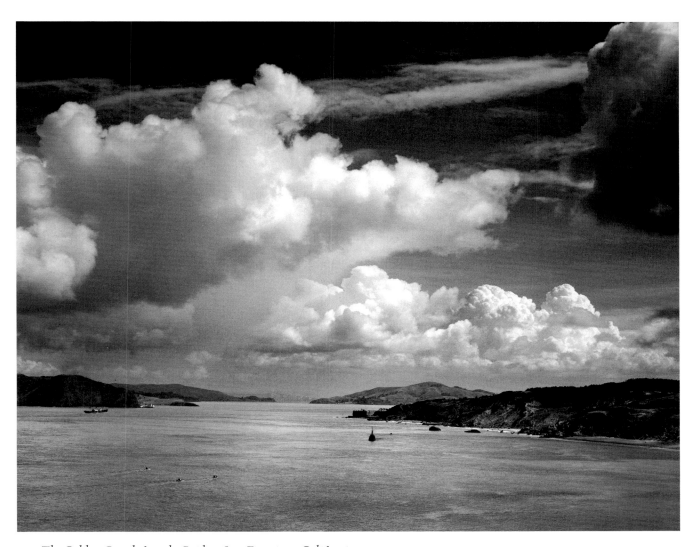

11. *The Golden Gate before the Bridge, San Francisco, California, 1932*

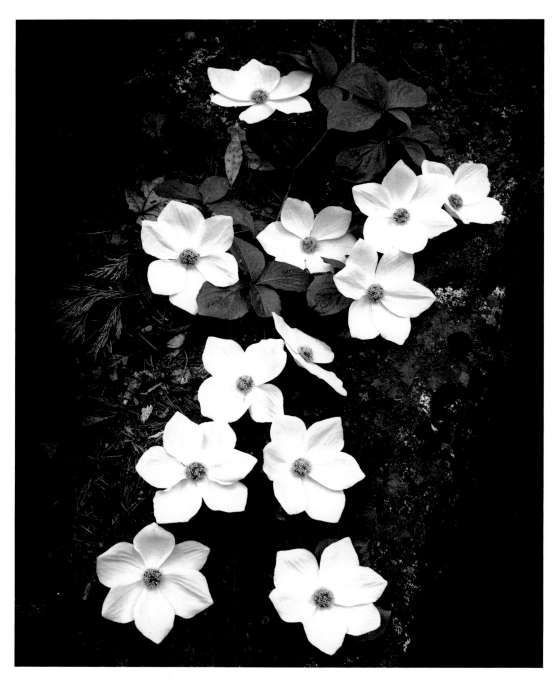

12. Dogwood, Yosemite National Park, California, 1938

13. *Grass and Pool, The Sierra Nevada, California, c. 1935*

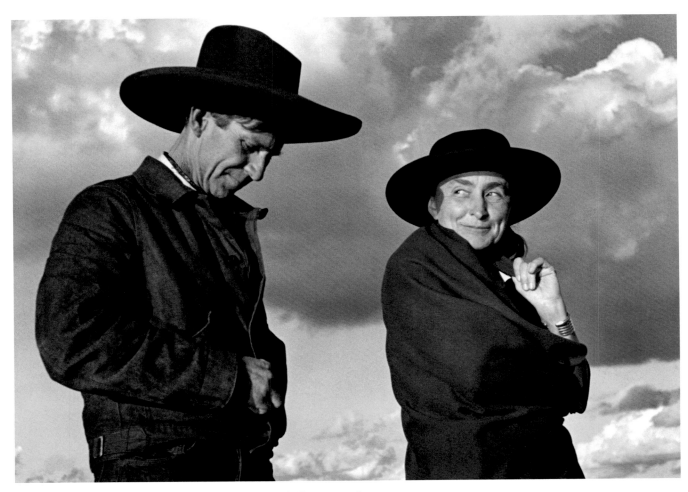

14. Georgia O'Keeffe and Orville Cox, Canyon de Chelly National Monument, Arizona, 1937

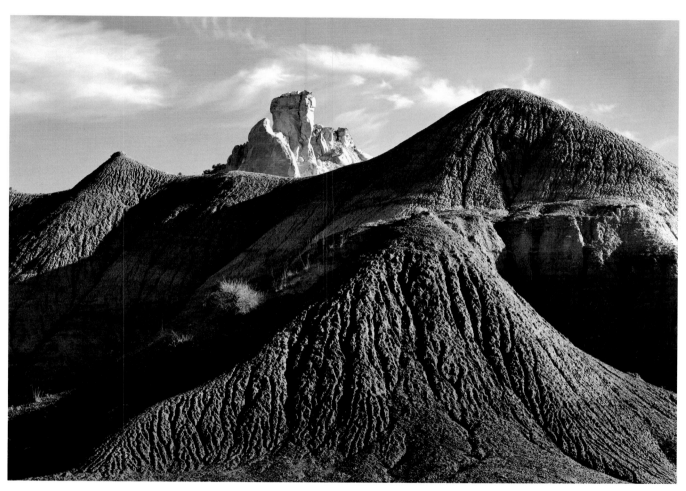

15. Ghost Ranch Hills, Chama Valley, Northern New Mexico, 1937

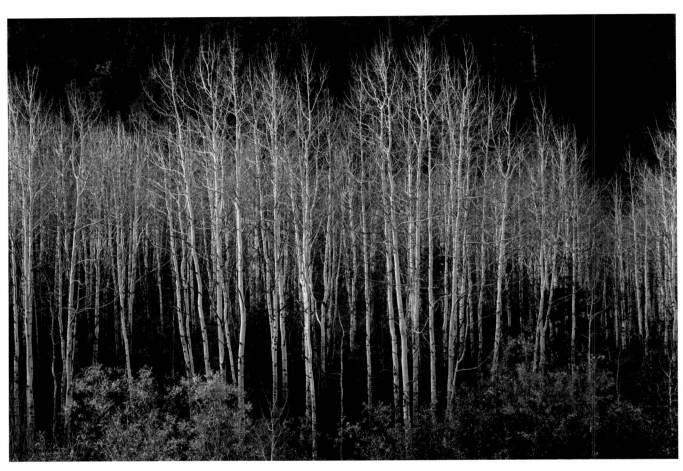

16. *Aspens, Dawn, Dolores River Canyon, Autumn, Colorado, 1937*

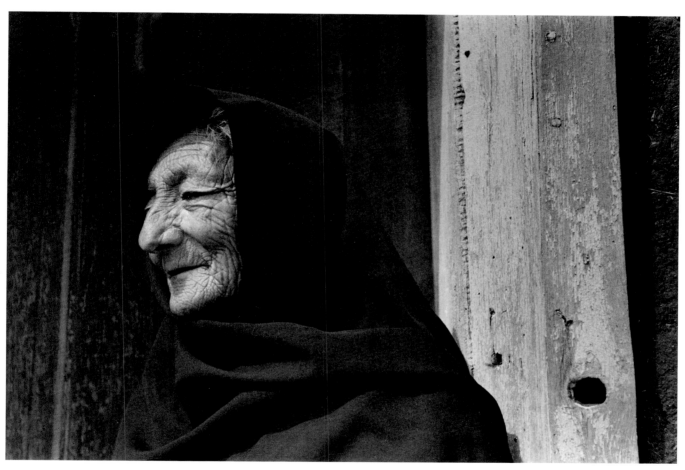

17. Spanish American Woman, near Chimayo, New Mexico, 1937

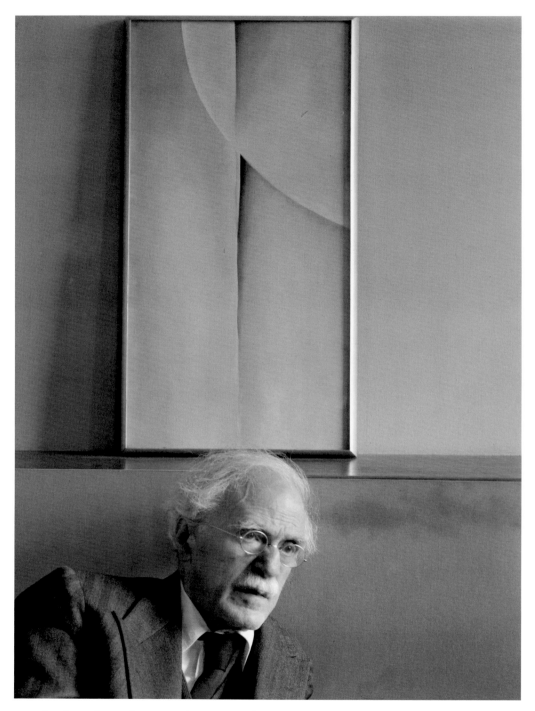

18. Alfred Stieglitz and Painting by Georgia O'Keeffe, An American Place, New York City, 1944

19. José Clemente Orozco, New York City, 1933

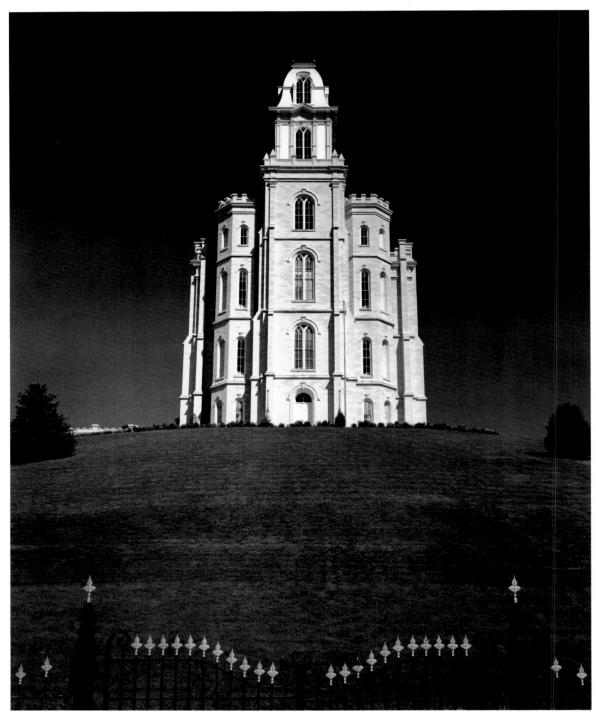

20. Mormon Temple, Manti, Utah, 1948

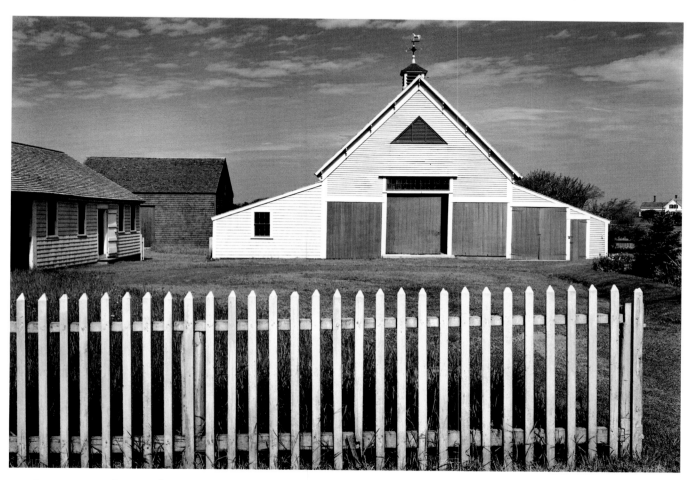

21. *Barn, Cape Cod, Massachusetts, c. 1937*

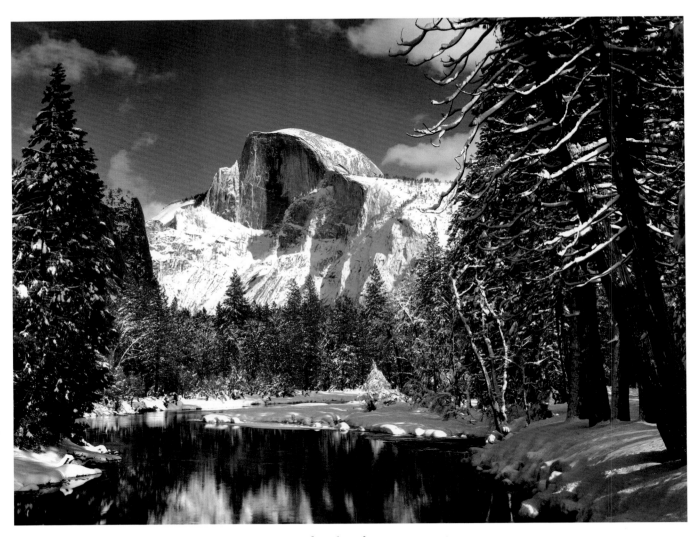

22. *Half Dome, Merced River, Winter, Yosemite National Park, California, c. 1938*

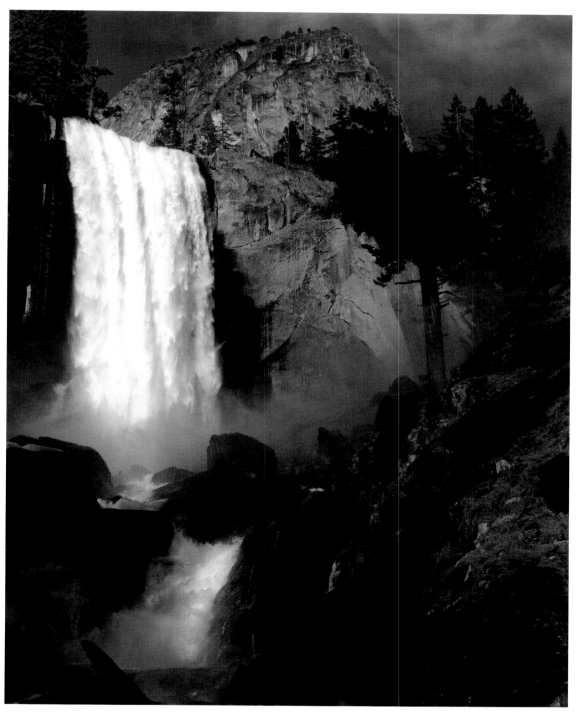

23. *Vernal Fall, Yosemite Valley, California, c. 1948*

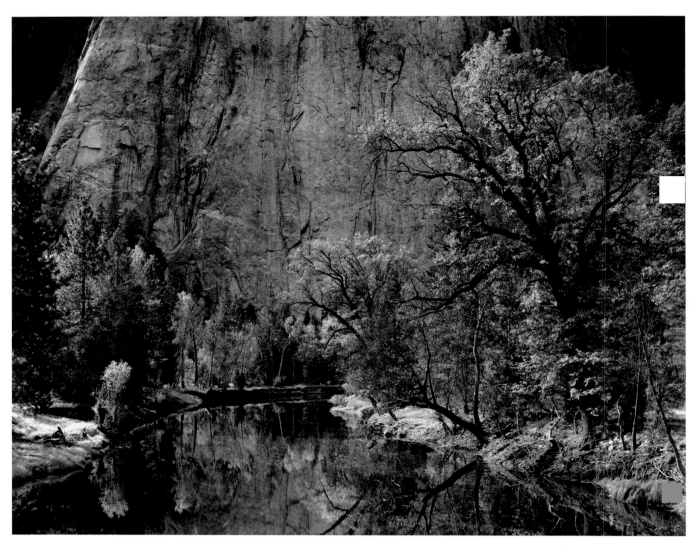

24. Merced River, Cliffs, Autumn, Yosemite Valley, California, c. 1939

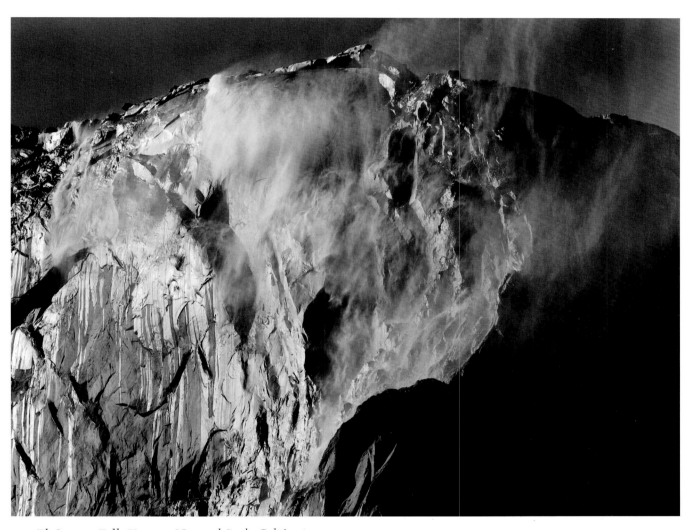

25. El Capitan Fall, Yosemite National Park, California, c. 1940

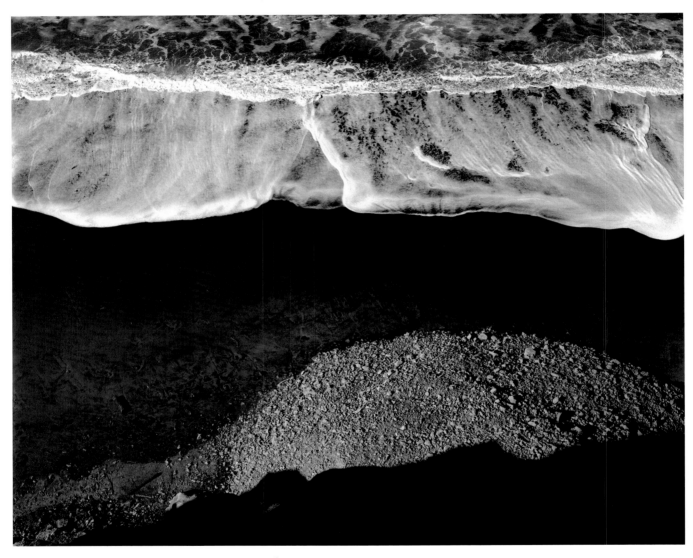

26. *Surf Sequence 1, San Mateo County Coast, California, 1940*

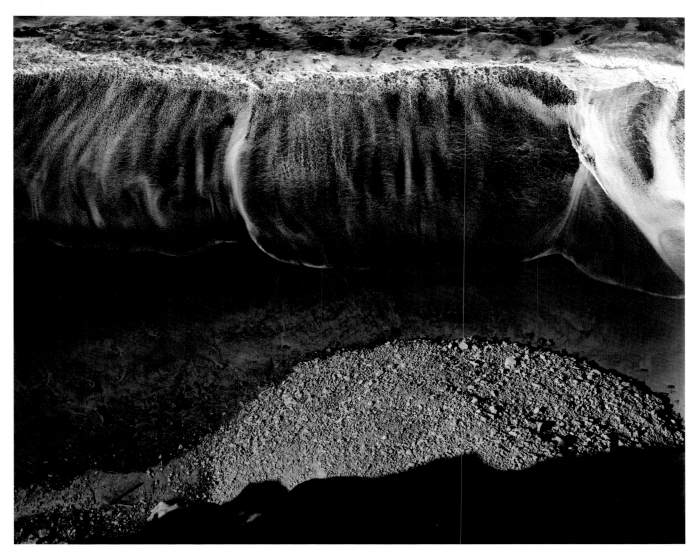

27. *Surf Sequence 2, San Mateo County Coast, California, 1940*

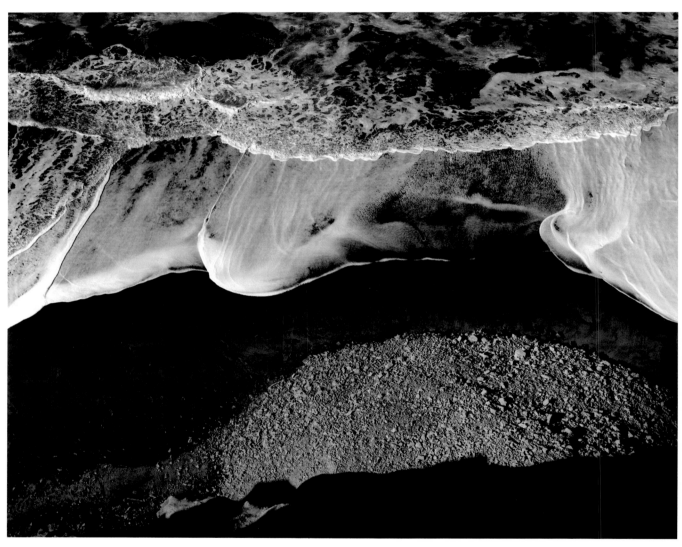

28. *Surf Sequence 3, San Mateo County Coast, California, 1940*

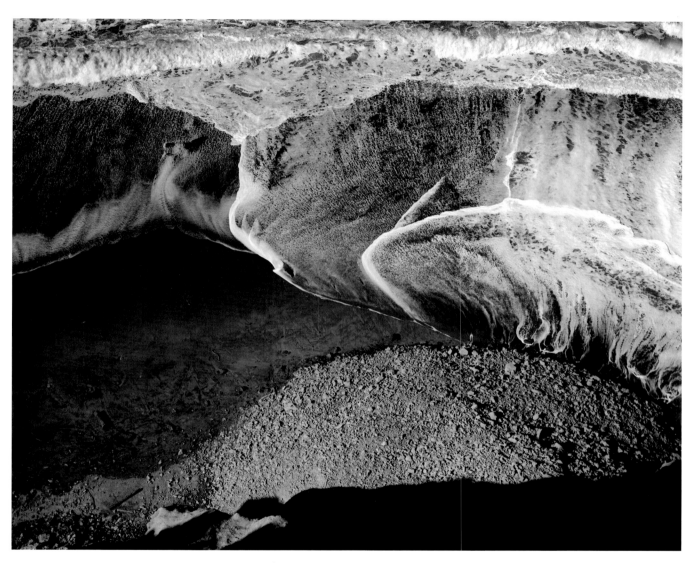

29. *Surf Sequence 4, San Mateo County Coast, California, 1940*

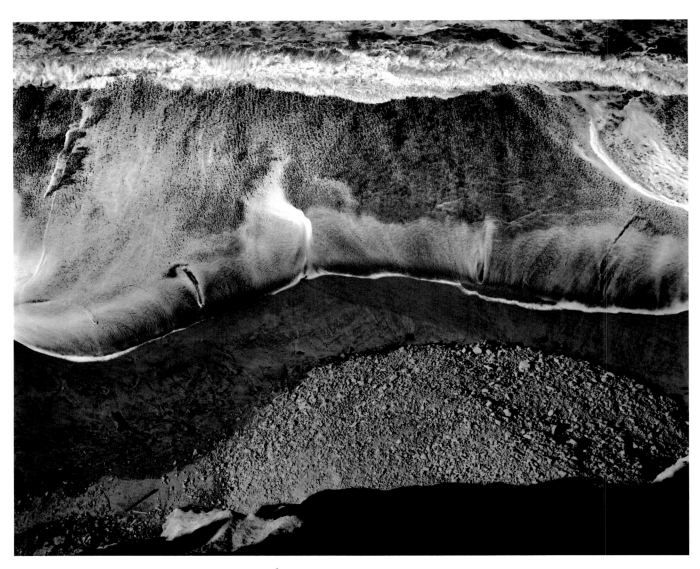

30. Surf Sequence 5, San Mateo County Coast, California, 1940

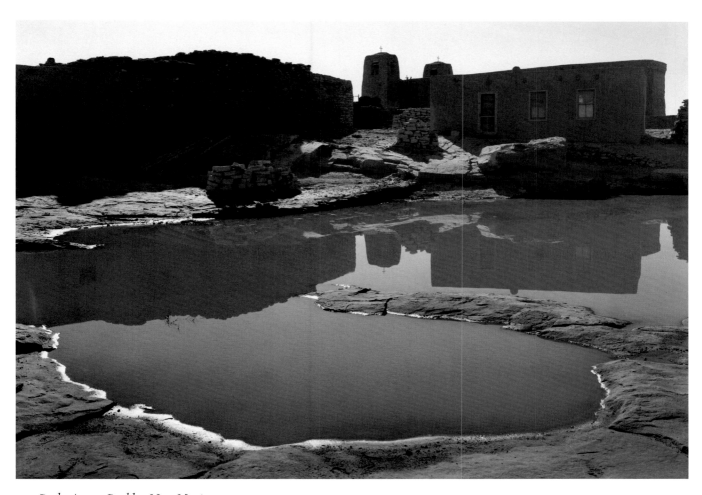

31. Pool, Acoma Pueblo, New Mexico, c. 1942

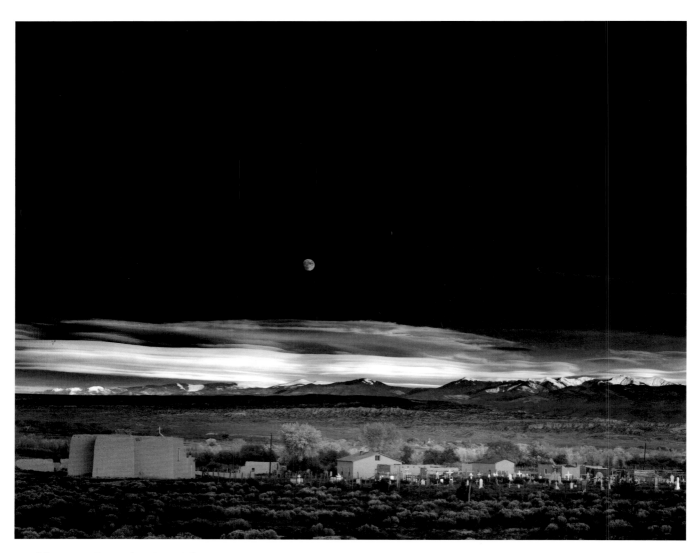

32. Moonrise, Hernandez, New Mexico, 1941

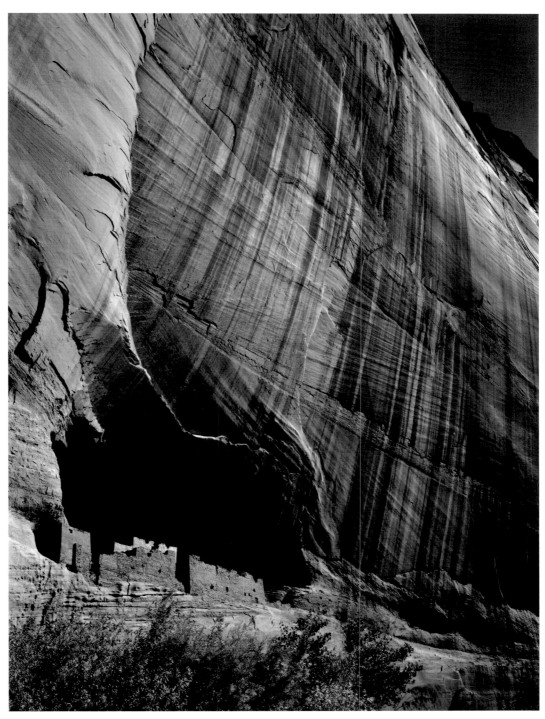

33. White House Ruin, Canyon de Chelly National Monument, Arizona, 1942

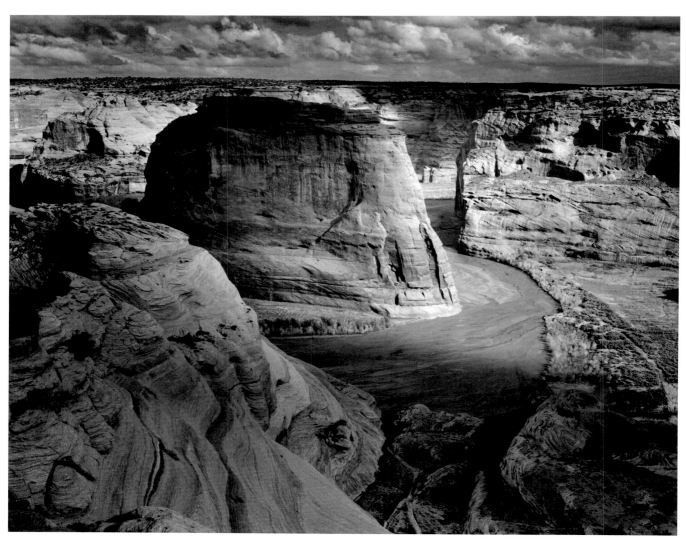

34. Canyon de Chelly National Monument, Arizona, 1942

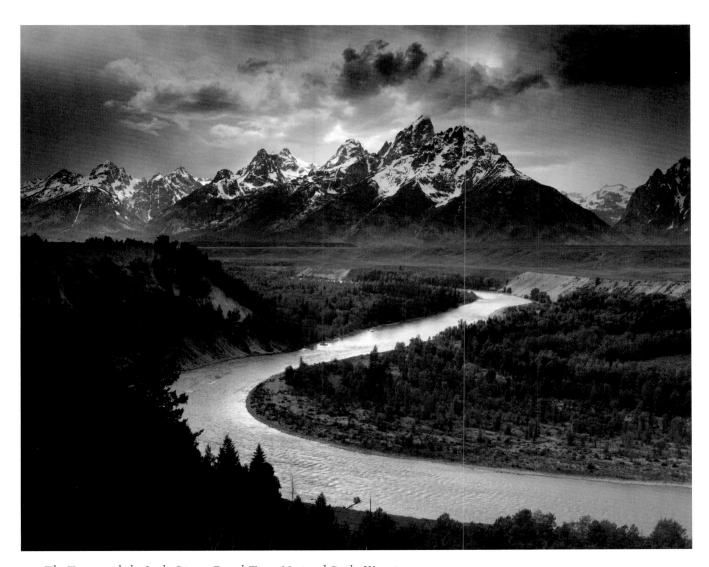

35. The Tetons and the Snake River, Grand Teton National Park, Wyoming, 1942

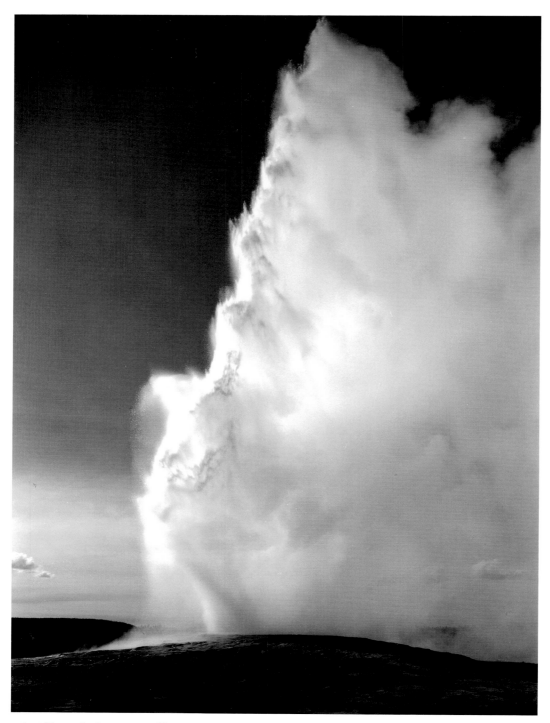

36. Old Faithful Geyser, Yellowstone National Park, Wyoming, 1942

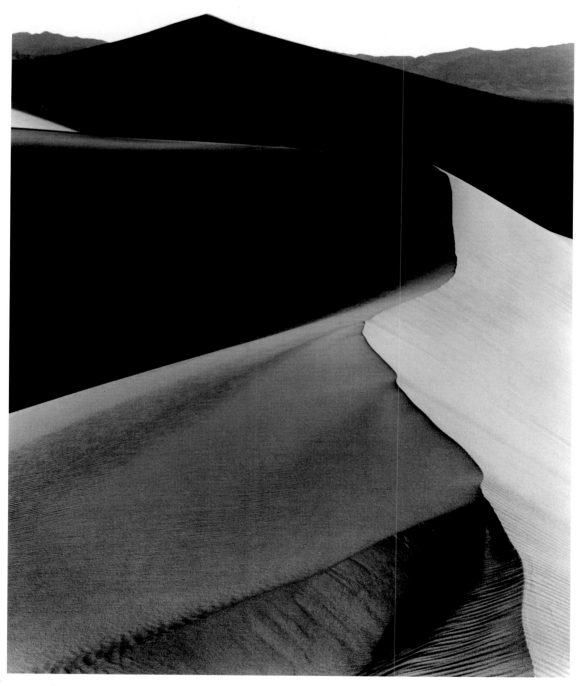

37. *Sand Dunes, Sunrise, Death Valley National Monument, California, c. 1948*

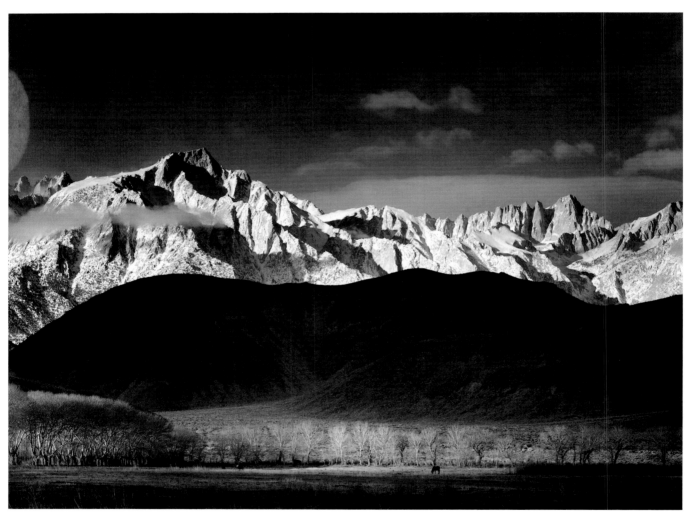

38. Winter Sunrise, The Sierra Nevada, from Lone Pine, California, 1944

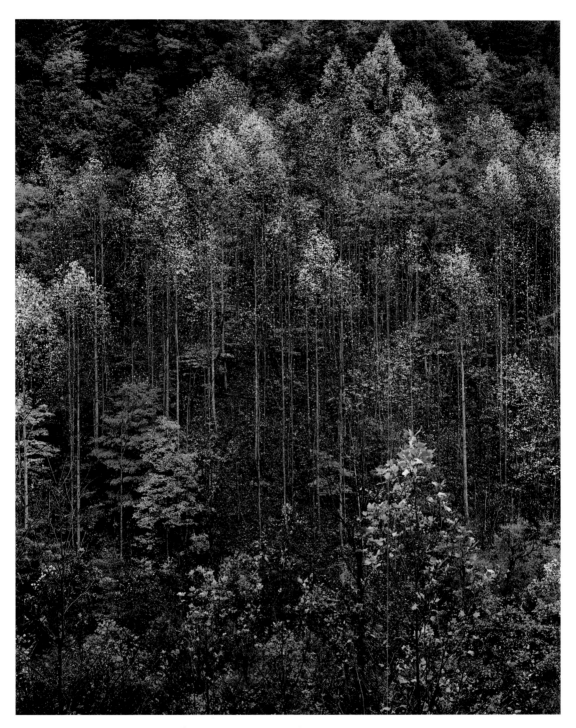

39. Dawn, Autumn, Great Smoky Mountains National Park, Tennessee, 1948

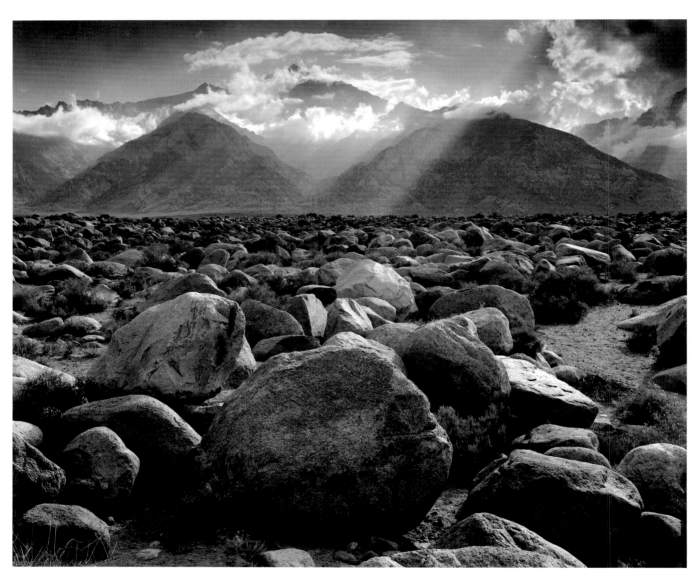

40. Mount Williamson, The Sierra Nevada, from Manzanar, California, 1945

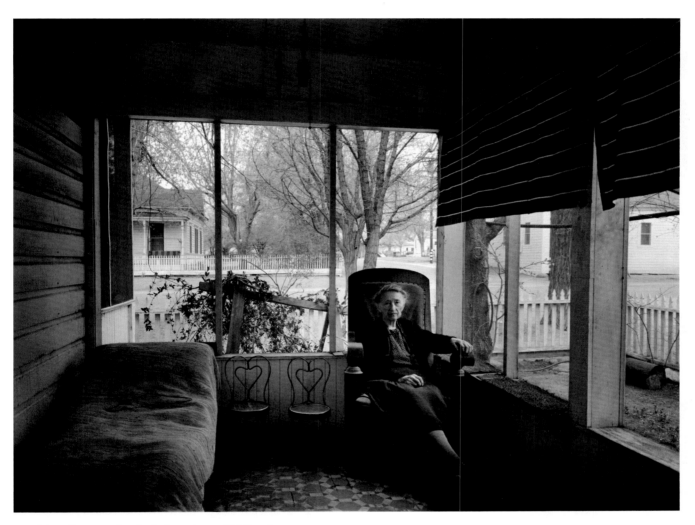

41. Mrs. Gunn on Porch, Independence, California, 1944

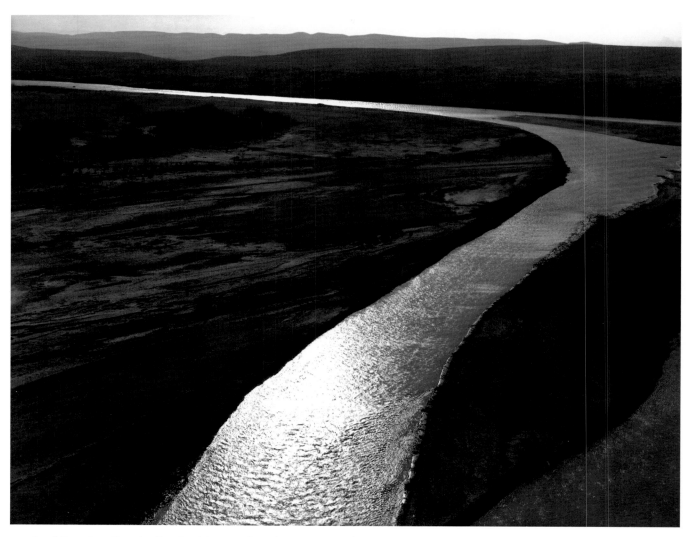

42. *Sand Bar, Rio Grande, Big Bend National Park, Texas, 1947*

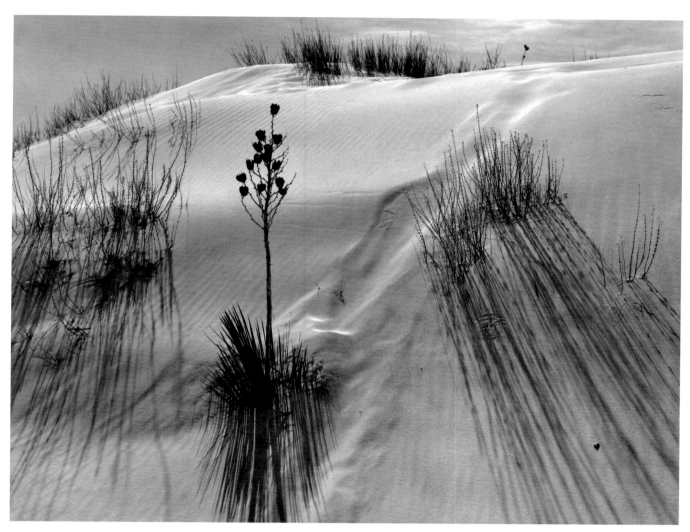

43. Dune, White Sands National Monument, New Mexico, c. 1942

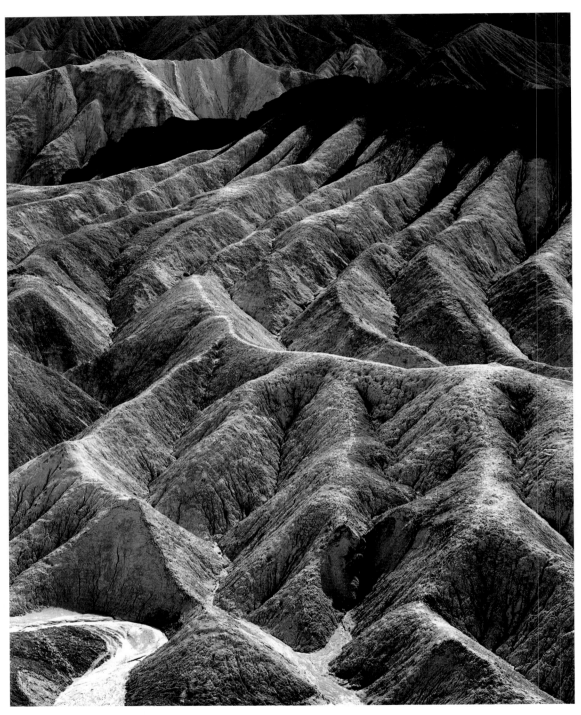

44. *Zabriskie Point, Death Valley National Monument, California, c. 1942*

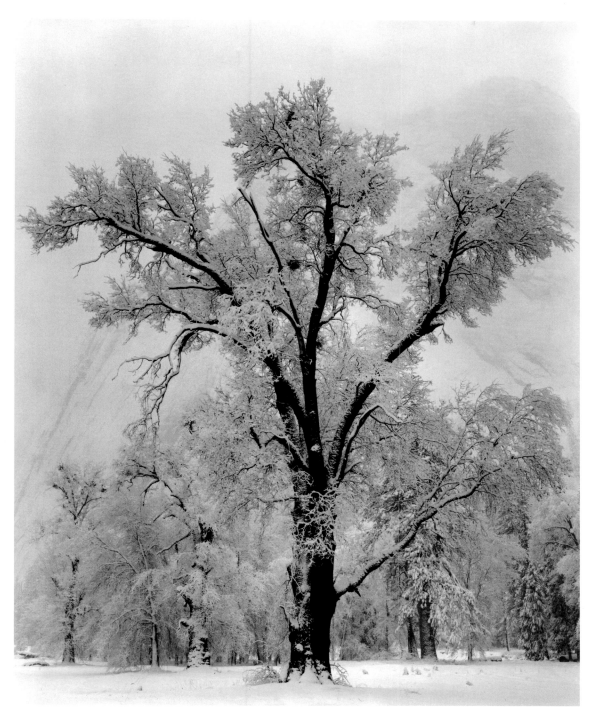

45. *Oak Tree, Snowstorm, Yosemite National Park, California, 1948*

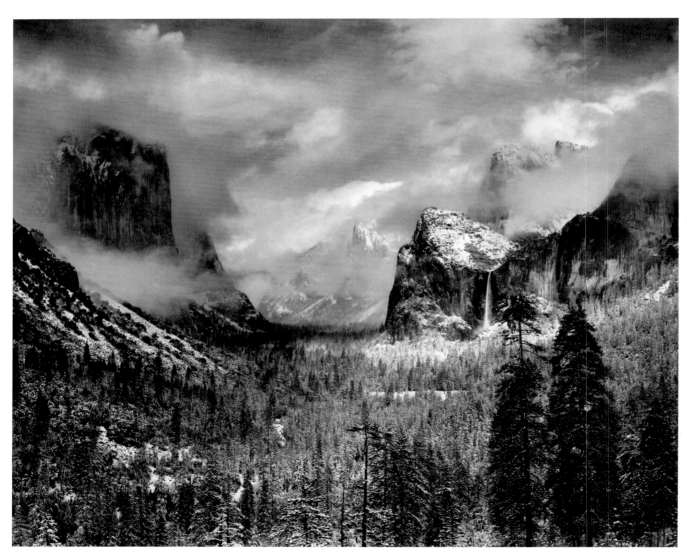

46. Clearing Winter Storm, Yosemite National Park, California, 1944

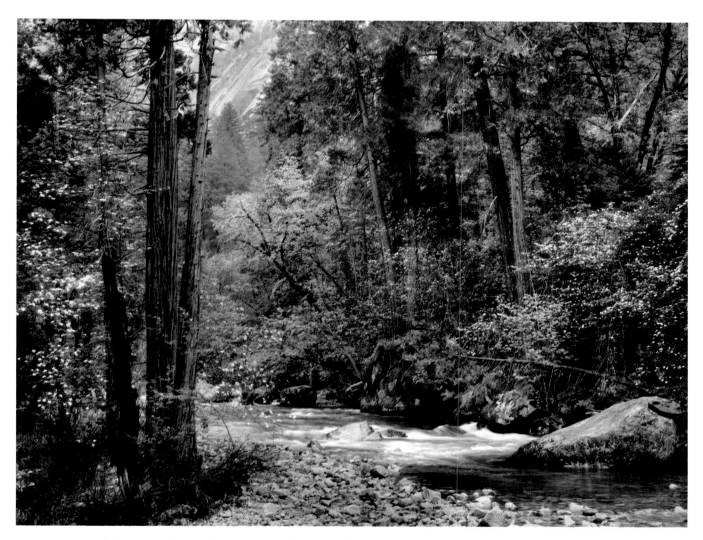

47. *Tenaya Creek, Dogwood, Rain, Yosemite National Park, California, c. 1948*

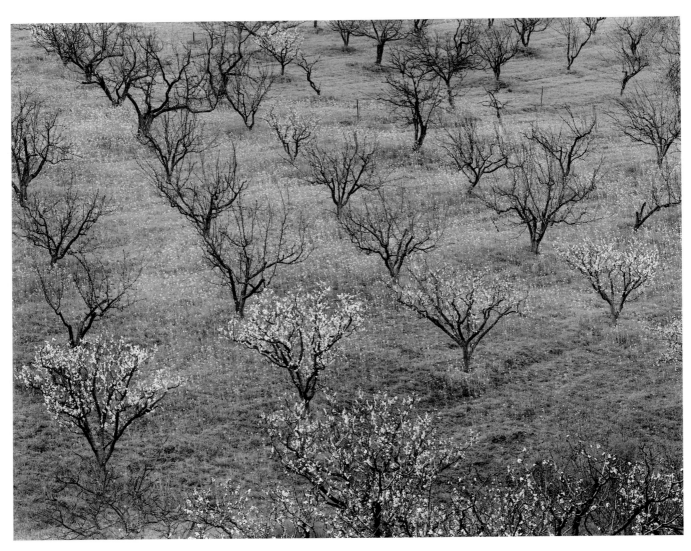

48. *Orchard, Portola Valley, California, c. 1940*

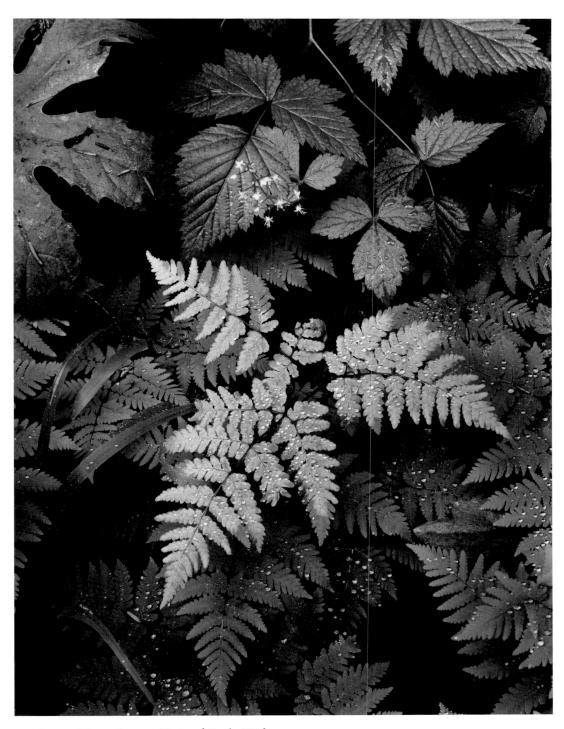

49. *Leaves, Mount Rainier National Park, Washington, c. 1942*

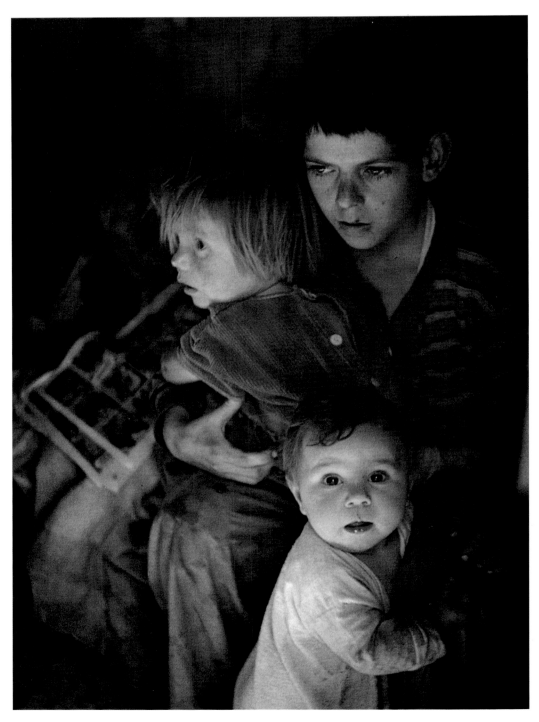

50. Trailer Camp Children, Richmond, California, 1944

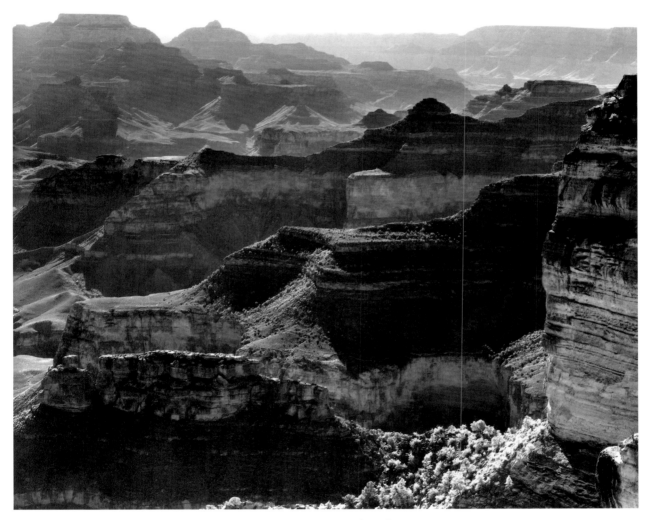

51. Grand Canyon of the Colorado River, Grand Canyon National Park, Arizona, c. 1942

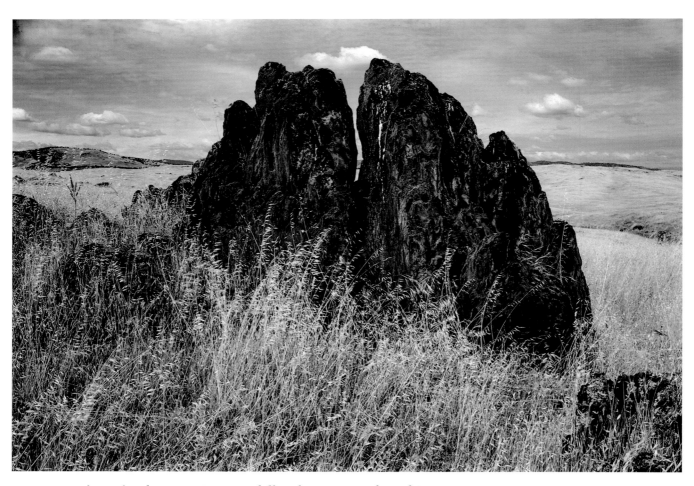

52. *Metamorphic Rock and Summer Grass, Foothills, The Sierra Nevada, California, 1945*

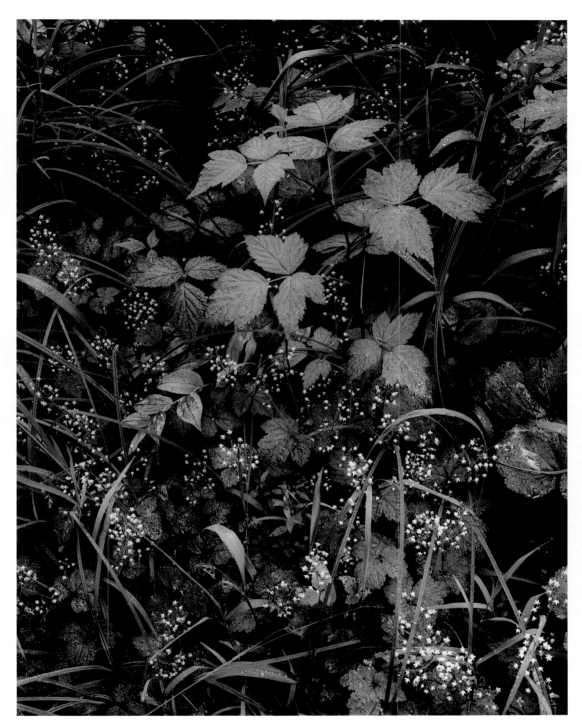

53. Trailside, near Juneau, Alaska, 1947

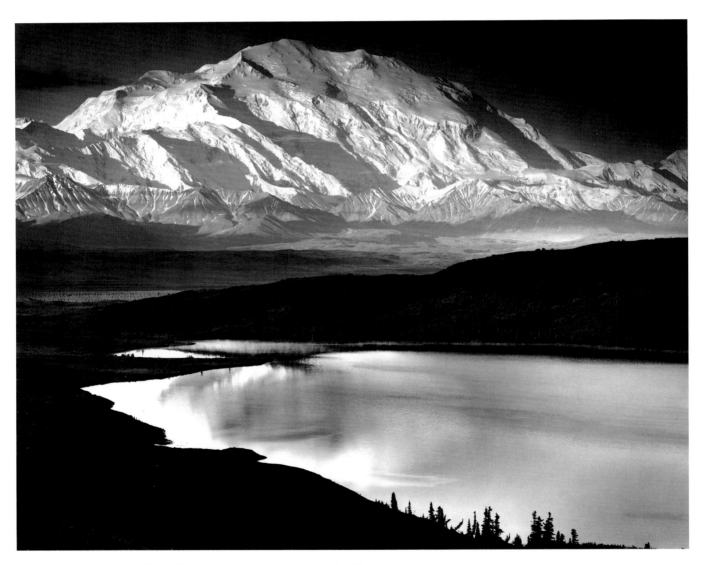

54. Mount McKinley and Wonder Lake, Denali National Park, Alaska, 1947

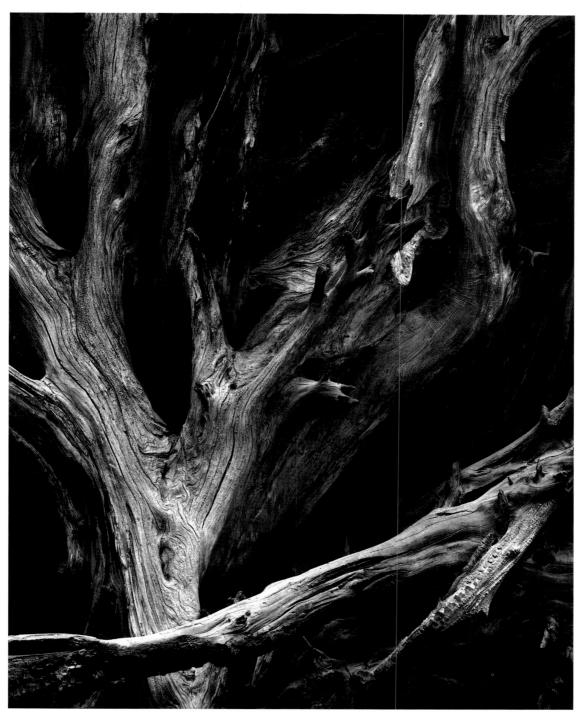

55. Sequoia Gigantea Roots, Yosemite National Park, California, c. 1950

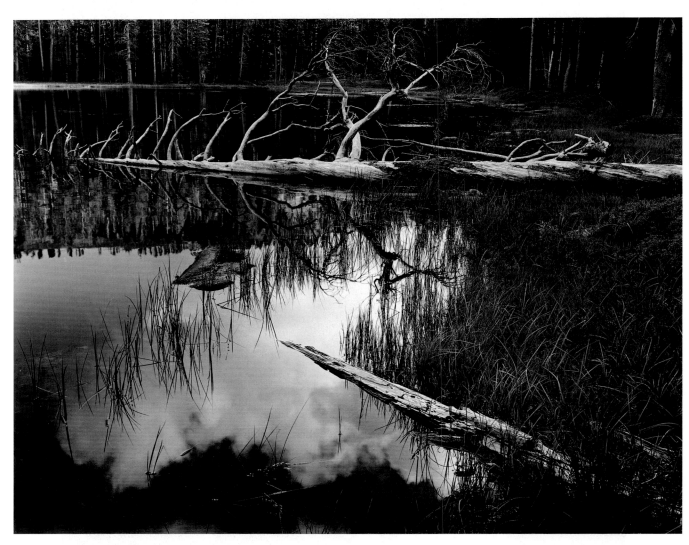

56. *Siesta Lake, Yosemite National Park, California, c. 1958*

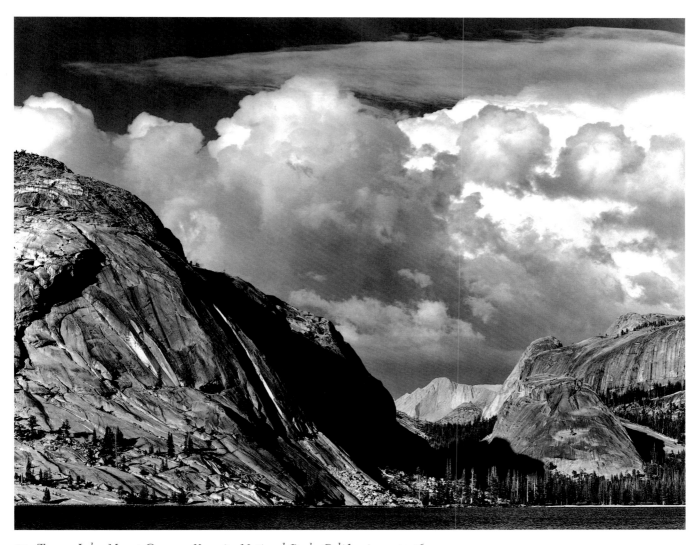

57. *Tenaya Lake, Mount Conness, Yosemite National Park, California, c. 1946*

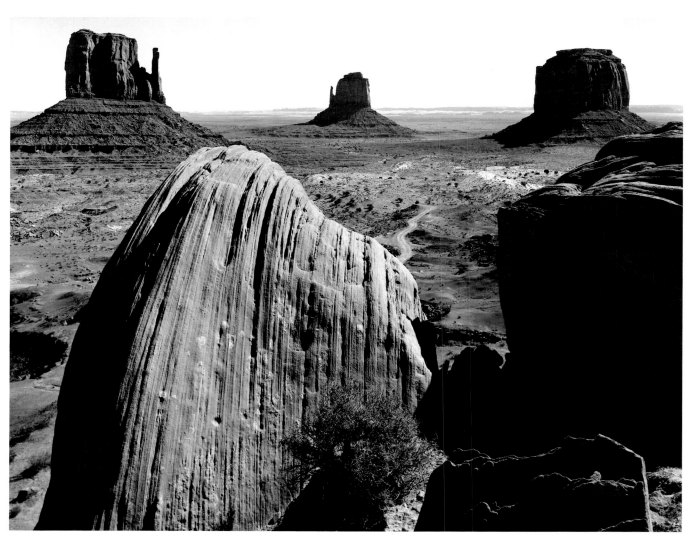

58. *Monument Valley, Arizona, 1958*

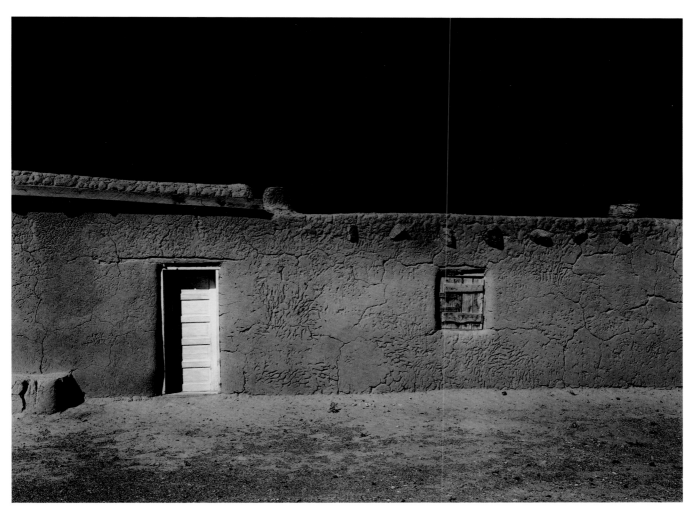

59. *Penitente Morada, Coyote, New Mexico, c. 1950*

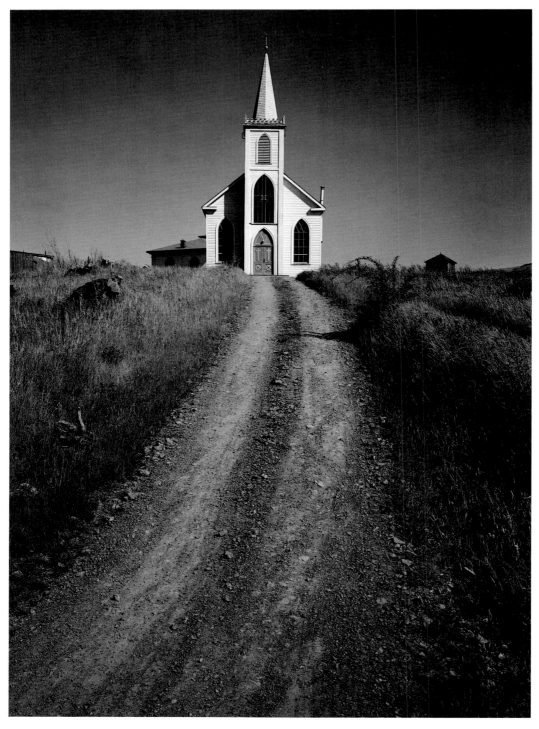

60. *Church and Road, Bodega, California, c. 1953*

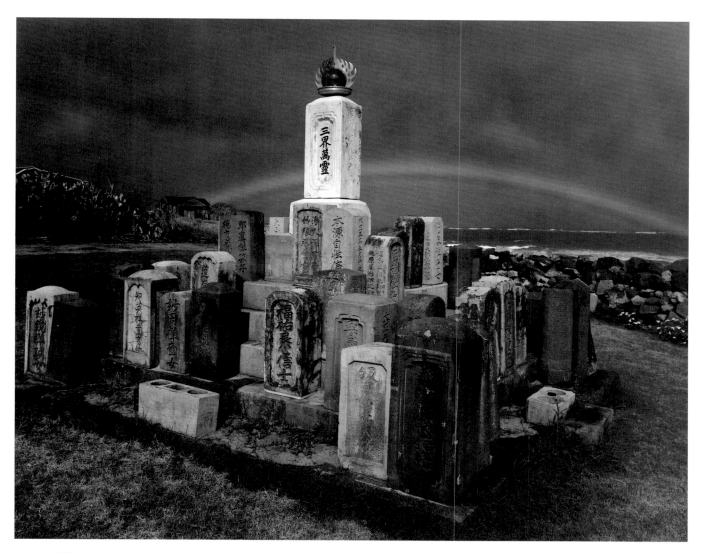

61. *Buddhist Grave Markers and Rainbow, Maui, Hawaii, c. 1956*

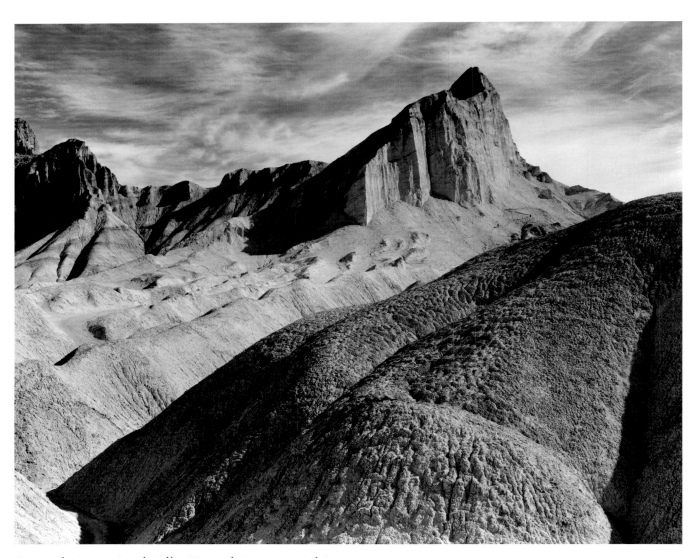

62. *Manly Beacon, Death Valley National Monument, California, c. 1952*

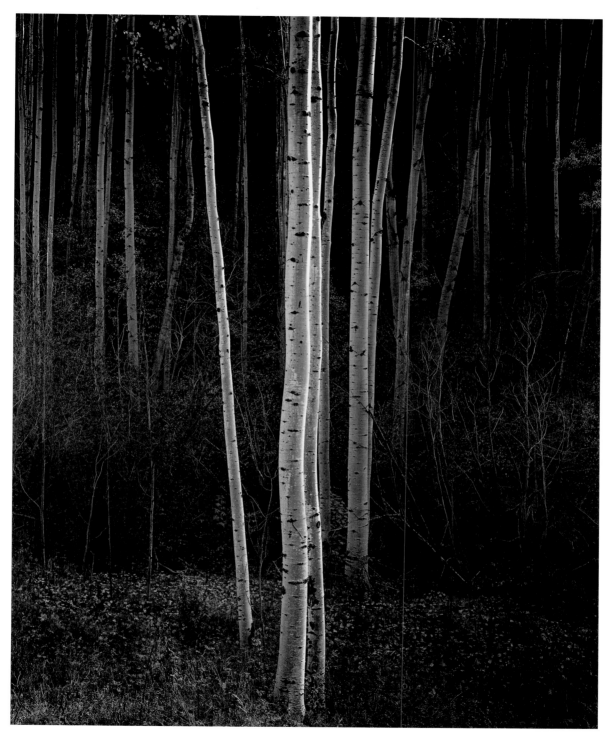

63. Aspens, Northern New Mexico, 1958

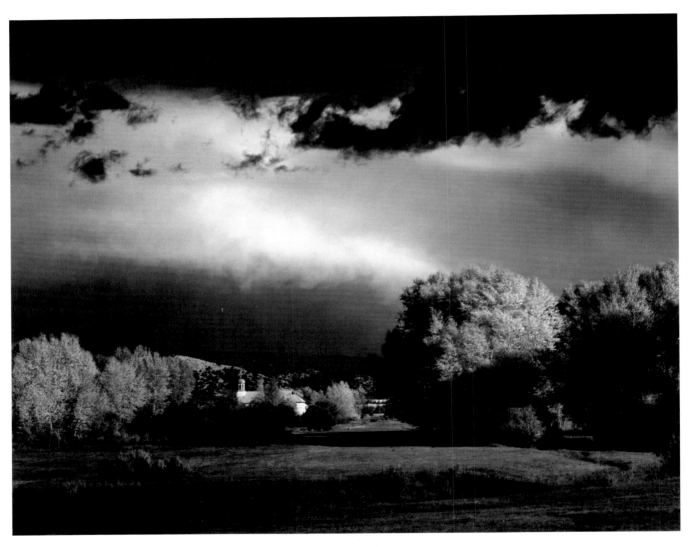

64. *Autumn Storm, Los Trampas, near Peñasco, New Mexico, c. 1958*

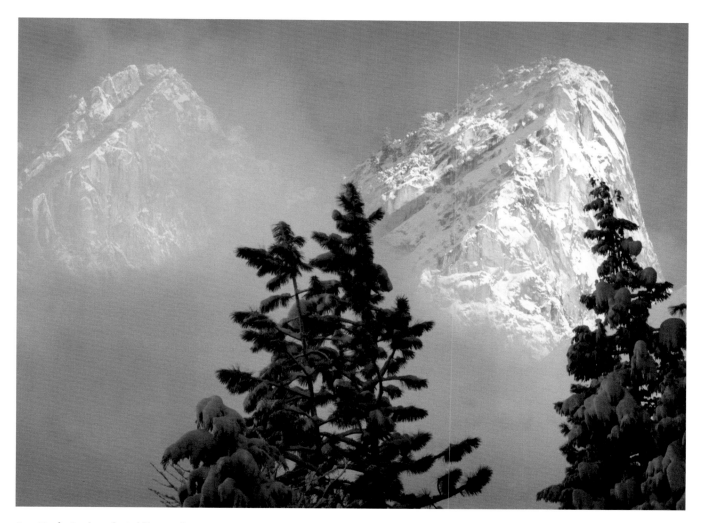

65. Eagle Peak and Middle Brother, Winter, Yosemite National Park, California, c. 1968

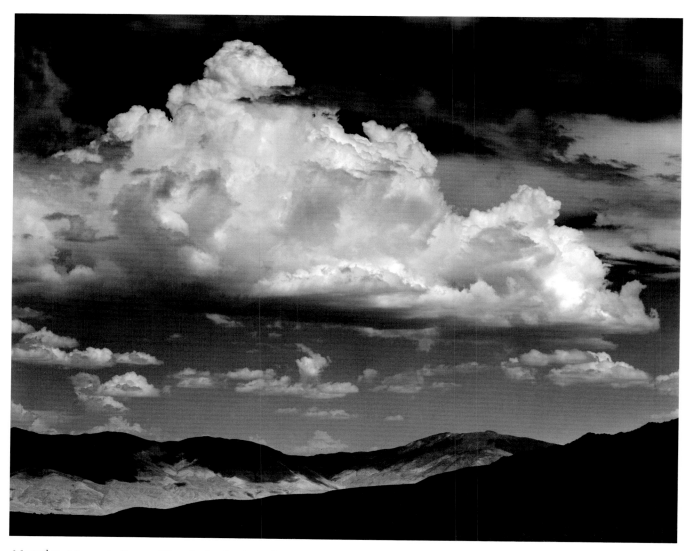

66. *White Mountain Range, Thunderclouds, from the Buttermilk Country, near Bishop, California, 1959*

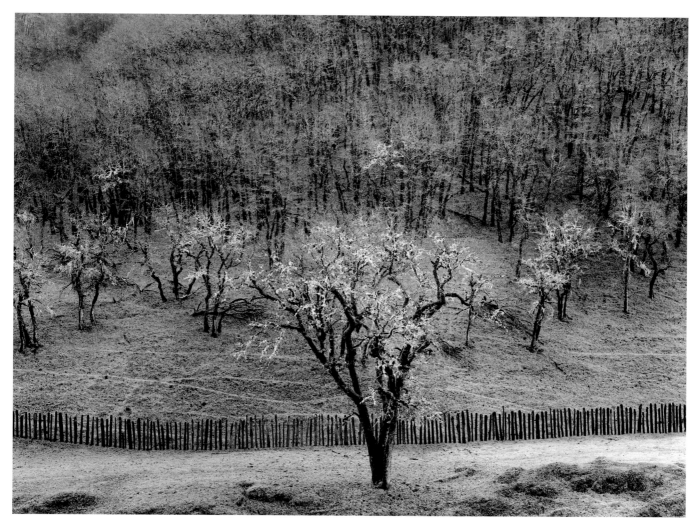

67. *Oak Tree, Rain, Sonoma County, California, c. 1960*

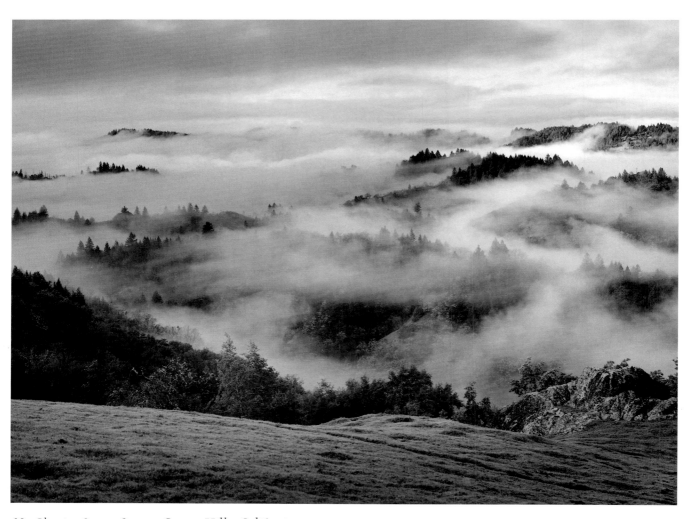

68. *Clearing Storm, Sonoma County Hills, California, 1951*

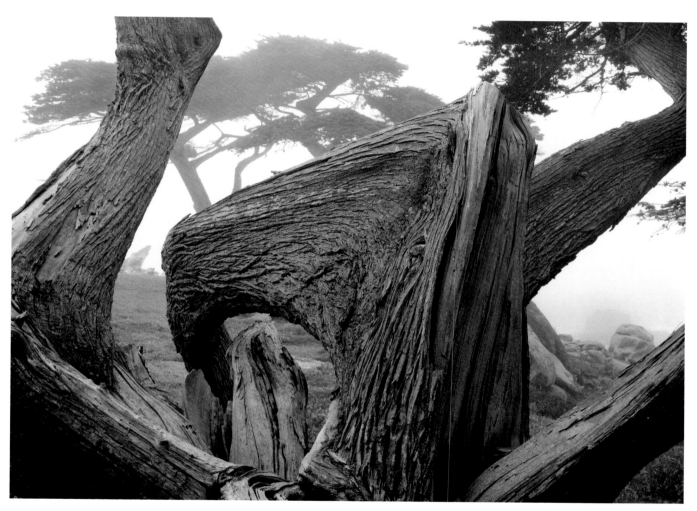

69. Cypress and Fog, Pebble Beach, California, 1967

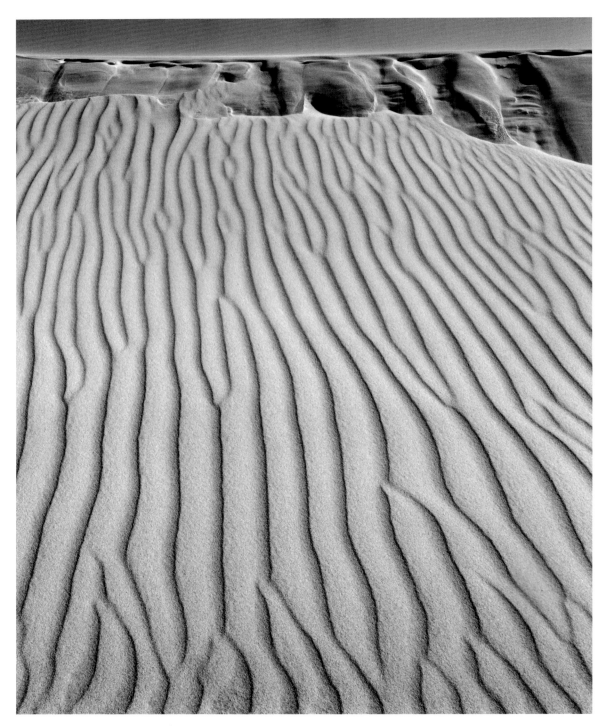

70. Sand Dunes, Oceano, California, c. 1950

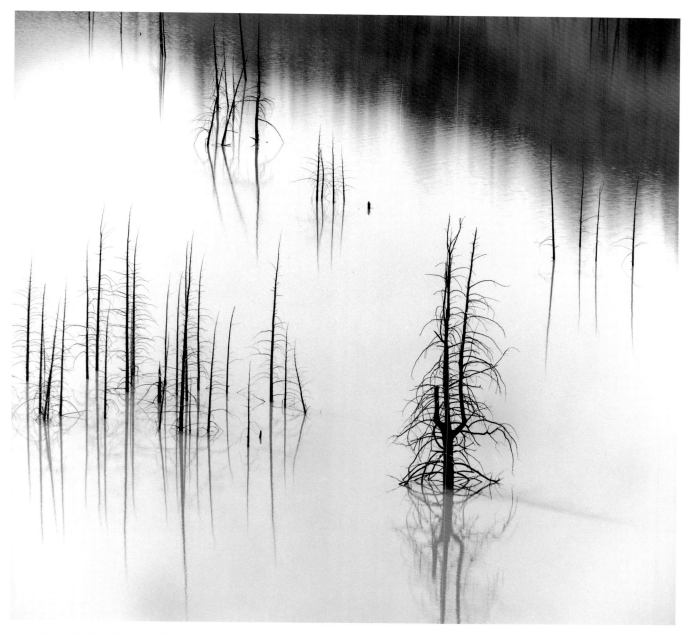

71. Trees, Slide Lake, Grand Teton National Park, c. 1965

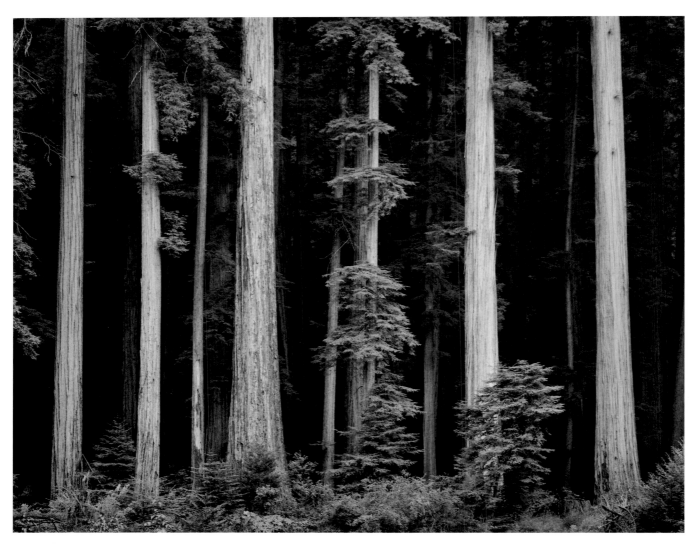

72. Redwoods, Bull Creek Flat, Northern California, c. 1960

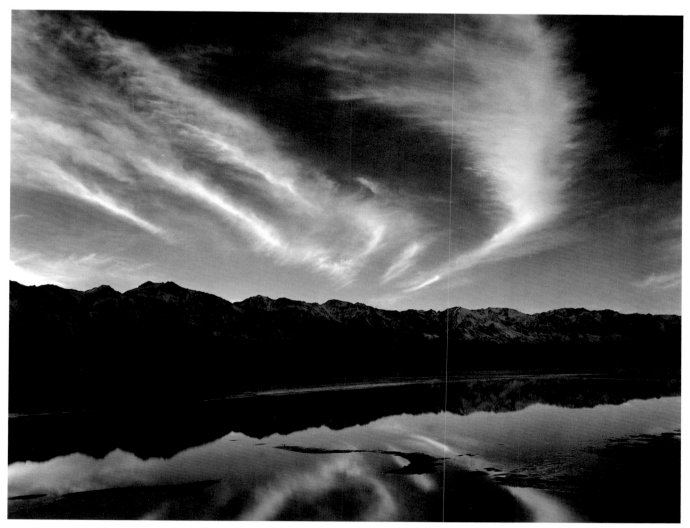

73. *Evening Clouds and Pool, East Side of The Sierra Nevada, from the Owens Valley, California, c. 1962*

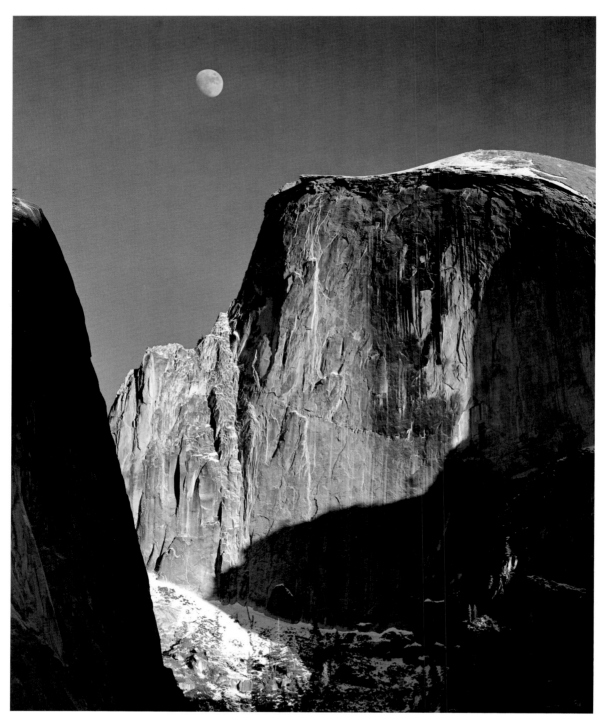

74. Moon and Half Dome, Yosemite National Park, California, 1960

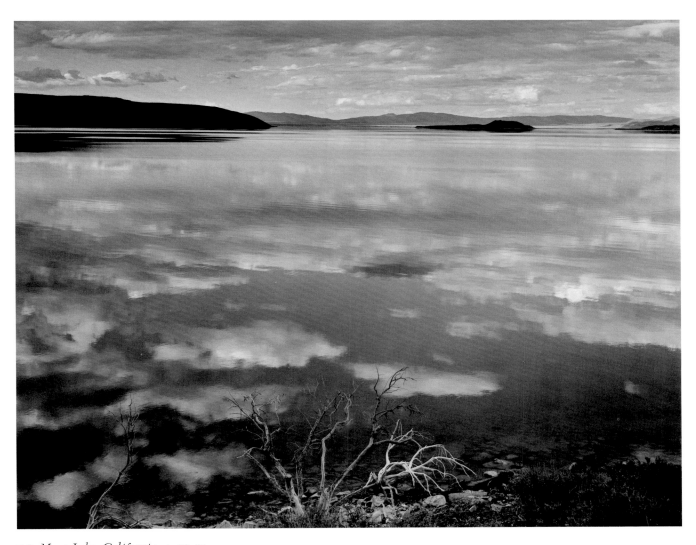

75. *Mono Lake, California, c. 1947*

List of Plates

54. *Mount McKinley and Wonder Lake, Denali National Park, Alaska, 1947*

55. *Sequoia Gigantea Roots, Yosemite National Park, California, c. 1950*

56. *Siesta Lake, Yosemite National Park, California, c. 1958*

57. *Tenaya Lake, Mount Conness, Yosemite National Park, California, c. 1946*

58. *Monument Valley, Arizona, 1958*

59. *Penitente Morada, Coyote, New Mexico, c. 1950*

60. *Church and Road, Bodega, California, c. 1953*

61. *Buddhist Grave Markers and Rainbow, Maui, Hawaii, c. 1956*

62. *Manly Beacon, Death Valley National Monument, California, c. 1952*

63. *Aspens, Northern New Mexico, 1958*

64. *Autumn Storm, Los Trampas, near Peñasco, New Mexico, c. 1958*

65. *Eagle Peak and Middle Brother, Winter, Yosemite National Park, California, c. 1968*

66. *White Mountain Range, Thunderclouds, from the Buttermilk Country, near Bishop, California, 1959*

67. *Oak Tree, Rain, Sonoma County, California, c. 1960*

68. *Clearing Storm, Sonoma County Hills, California, 1951*

69. *Cypress and Fog, Pebble Beach, California, 1967*

70. *Sand Dunes, Oceano, California, c. 1950*

71. *Trees, Slide Lake, Grand Teton National Park, c. 1965*

72. *Redwoods, Bull Creek Flat, Northern California, c. 1960*

73. *Evening Clouds and Pool, East Side of The Sierra Nevada, from the Owens Valley, California, c. 1962*

74. *Moon and Half Dome, Yosemite National Park, California, 1960*

75. *Mono Lake, California, c. 1947*

A Chronology

James Alinder

1902
Born Ansel Easton Adams on February 20, at 114 Maple
Street, San Francisco, the only child of Olive Bray and
Charles Hitchcock Adams. The family home is com-
pleted the next year at 129 Twenty-fourth Avenue, in
the sand dune area overlooking the Golden Gate.

1906
Family survives the great San Francisco earthquake,
though Ansel falls during an aftershock and breaks his
nose.

1907
Grandfather Adams dies and family lumber business fails.
Charles Hitchcock Adams spends the rest of his life
attempting to repay the debts of the failed business.

1908
An enormously curious and gifted child, Ansel begins a
precarious journey through the rigid structure of the
school system. Grandfather Bray and Aunt Mary Bray
come to live with his family. Father's parents' home,
"Unadilla," in Atherton, California, burns to the ground.

1914
Teaches himself to play the piano and excels at serious
music study with Marie Butler.

1915
Despises the regimentation of a regular education, and is
taken out of school. For that year's education, his father
buys him a season pass to the Panama-Pacific Exposition,
which he visits nearly every day. Private tutors later
provide continuing education.

1916
Convinces parents to take family vacation in Yosemite
National Park. Begins to photograph there, using father's
box Brownie camera and develops an enthusiastic interest
in both photography and the national park. Returns to
Yosemite every year for the rest of his life.

1917
Receives grammar school diploma from the Mrs. Kate
M. Wilkins Private School, San Francisco. Though
largely self-taught in photography, he works that summer
and the next at Frank Dittman's photo-finishing business.

1920
Spends the first of four summers as the custodian of the
Sierra Club headquarters in Yosemite. Photography
becomes more than a hobby as he begins to articulate his
ideas about the creative potentials of the medium.
Continues piano studies with professional ambitions,
studying with Frederick Zech.

1921
Spends second summer in Yosemite. Finds a piano to
practice on at Best's Studio, a Yosemite concession selling
paintings, photographs, and gifts. Meets Harry Best's
daughter, Virginia. Takes first high-country trip into the
Sierra with Francis "Uncle Frank" Holman and
Mistletoe, the burro.

1922
Publishes first article, on the Lyell Fork of the Merced River, in the Sierra Club *Bulletin*.

1924
Explores Kings River Canyon with the Le Conte family. Takes a similar trip the following summer.

1925
Decides to become a concert pianist and purchases a Mason and Hamlin grand piano, the finest available.

1926
Takes first trip to Carmel with Albert Bender, who becomes his first patron; meets Robinson Jeffers there.

1927
Makes the photograph *Monolith, the Face of Half Dome*. He considers this image to be his first "visualization," using the term to describe the photographer's pre-exposure determination of the visual and emotional qualities of the finished print. Publishes initial portfolio, *Parmelian Prints of the High Sierras* [sic] (San Francisco: Jean Chambers Moore). Goes on first Sierra Club outing. Travels with Bender in California and New Mexico, meets Mary Austin, Witter Bynner, and others.

1928
Marries Virginia Best in Yosemite. First one-man exhibition held at the Sierra Club, San Francisco. His photographs will be included in more than five hundred exhibitions during his lifetime.

1929
Photographs at Taos Pueblo in northern New Mexico for a book project. In Taos, meets Georgia O'Keeffe and John Marin at Mabel Dodge Luhan's estate. In Yosemite, writes words, selects music and acts a leading role for The Bracebridge Dinner, a Christmas production that becomes an annual event.

1930
Meets Paul Strand in Taos, becomes committed to a full-time career in photography after understanding Strand's total dedication to creative photography and seeing his negatives. Builds home and studio at 131 Twenty-fourth Avenue, San Francisco, adjoining parents' home. Publishes *Taos Pueblo*, containing twelve original photographs with text by Mary Austin. Begins accepting commercial photography assignments, one of the first

being catalogue pictures for Gump's, the unique San Francisco specialty store. Continues commercial work into the early 1970s.

1931
Begins writing photography column for *The Fortnightly*; reviews Eugene Atget and Edward Weston exhibitions at San Francisco's M. H. de Young Memorial Museum. Exhibition of sixty prints at the Smithsonian Institute.

1932
Founding member of Group *f*/64, and is a part of the renowned Group *f*/64 exhibition at the de Young; also has one-man show there. Makes the photograph *Frozen Lake and Cliffs*.

1933
Son Michael born. Meets Alfred Stieglitz at his gallery An American Place in New York City. Opens Ansel Adams Gallery at 166 Geary Street, San Francisco, after return. First New York City exhibition at Delphic Studio.

1934
Begins publishing a series of technical articles, "An Exhibition of my Photographic Technique," in *Camera Craft*. Writes a coherent thesis of his aesthetic beliefs, "The New Photography," *Modern Photography 1934–35* (London and New York: The Studio Publications). Elected to the Board of Directors of the Sierra Club.

1935
Daughter Anne born. Publishes technical book, *Making a Photograph; An Introduction to Photography* (The Studio Publications). First publication of his "Personal Credo" in *Camera Craft*. Teaches in Art Students League Workshop in San Francisco.

1936
One-man exhibition at An American Place. Lobbies congressmen in Washington, D.C., on behalf of the Sierra Club for the establishment of Kings Canyon National Park. Virginia inherits Best's Studio after her father's death.

1937
They move to Yosemite in the spring, where they take over the proprietorship of Best's Studio. His darkroom burns, destroying twenty percent of his negatives. He continues to work and maintain his professional studio in San Francisco. Takes photography treks with Edward

Weston through the High Sierra and with Georgia O'Keeffe and David McAlpin through the Southwest. Photographs included in first photography exhibition at the Museum of Modern Art, New York City. Hires Rondal Partridge as photographic assistant through 1940.

1938
Takes O'Keeffe and McAlpin through Yosemite and on High Sierra explorations. Photographs with Edward Weston in the Owens Valley. Publishes *Sierra Nevada: The John Muir Trail* (Berkeley: Archetype Press).

1939
Meets Beaumont and Nancy Newhall in New York. Has major exhibition at the San Francisco Museum of Modern Art.

1940
Teaches first workshop, the U.S. Camera Photographic Forum, in Yosemite with Edward Weston. Organizes the exhibition and edits the catalogue for *The Pageant of Photography* held at the Palace of Fine Arts, San Francisco. Helps to found the Department of Photography at the Museum of Modern Art, New York, with Newhall and McAlpin.

1941
Develops his Zone System technique of exposure and development control while teaching at Art Center School in Los Angeles. Begins to photograph for the Department of the Interior, but project is canceled because of world events in 1942. Makes his best-known photograph, *Moonrise, Hernandez, New Mexico*, on October 31 at 4:05 p.m. Publishes *Michael and Anne in Yosemite Valley*, text by Virginia Adams (The Studio Publications).

1942
Makes the photographs *The Tetons and Snake River* and *Leaves, Mount Rainier*.

1943
Photographs at Manzanar Relocation Center, begins "Born Free and Equal" photo-essay on the loyal Japanese-Americans interned there.

1944
Makes the photographs *Clearing Winter Storm* and *Winter Sunrise*. Paul Strand visits in Yosemite. Publishes *Born Free and Equal* (New York: U.S. Camera).

1945
Makes the photograph *Mount Williamson*.

1946
Receives John Solomon Guggenheim Memorial Foundation Fellowship to photograph the National Parks and Monuments. Founds Department of Photography at the California School of Fine Arts in San Francisco, later renamed the San Francisco Art Institute. Hires Minor White to teach with him. Publishes *Illustrated Guide to Yosemite Valley*, with Virginia Adams (San Francisco: H. S. Crocker).

1947
Does extensive photography in the national parks, makes first photographic trips to Alaska and Hawaii. Makes the photographs *White Branches, Mono Lake*, and *Mount McKinley and Wonder Lake*.

1948
Guggenheim Fellowship renewed. Makes the photographs *Sand Dunes, Sunrise*, and *Tenaya Creek, Dogwood, Rain*. Begins lifelong friendship with Dr. Edwin Land. Sierra Club publishes *Portfolio I*, with twelve Adams photographs. Publishes Basic Photo Series 1: *Camera and Lens*, and 2: *The Negative* (New York: Morgan & Morgan) and *Yosemite and the High Sierra*, edited by Charlotte E. Mauk with the selected words of John Muir (Boston: Houghton Mifflin).

1949
Becomes consultant for newly founded Polaroid Corporation.

1950
Sierra Club publishes *Portfolio II, The National Parks & Monuments*, with fifteen photographs. Publishes Basic Photo Series 3: *The Print* (Morgan & Morgan), *My Camera in Yosemite Valley* (Yosemite: V. Adams, and Boston: Houghton Mifflin), *My Camera in the National Parks* (Yosemite: V. Adams, and Boston: Houghton Mifflin) and a reprint of the 1903 title *The Land of Little Rain*, text by Mary Austin, with Ansel Adams' photographs (Houghton Mifflin). His mother, Olive, dies.

1951
His father, Charles, dies. Hires Pirkle Jones as his photographic assistant through 1953.

1952
Publishes Basic Photo Series 4: *Natural-Light Photography* (Morgan & Morgan). Exhibition at the George Eastman House, Rochester. Helps found *Aperture*, a journal of creative photography, with the Newhalls, Minor White, and others.

1953
Does *Life* photo-essay with Dorothea Lange on the Mormons in Utah.

1954
Publishes *Death Valley* (Palo Alto: 5 Associates), *Mission San Xavier del Bac* (5 Associates) and *The Pageant of History in Northern California* (San Francisco: American Trust Co.). Nancy Newhall contributes the text for all three books.

1955
The Ansel Adams Yosemite Workshop, an intense short-term creative photography learning experience, begins as an annual event.

1956
Organizes with Nancy Newhall the exhibition *This is the American Earth* for circulation by the United States Information Service (USIS). Publishes Basic Photo Series 5: *Artificial-Light Photography* (Morgan & Morgan). Don Worth becomes a photographic assistant through 1960, and Gerry Sharpe works on special projects through the early 1960s.

1957
Begins producing small, unsigned Special Edition Prints of a number of his Yosemite photographs, printed by assistants and for sale only at Best's Studio as a quality souvenir of the park. Film *Ansel Adams, Photographer* produced by Larry Dawson and directed by David Meyers; script by Nancy Newhall, narrated by Beaumont Newhall.

1958
Receives third Guggenheim Fellowship. Makes the photographs *Aspens, Northern New Mexico* in both horizontal and vertical formats. Publishes *The Islands of Hawaii*, text by Edward Joesting (Honolulu: Bishop National Bank of Hawaii). Presented Brehm Memorial Award for distinguished contributions to photography by the Rochester Institute of Technology.

1959
Publishes *Yosemite Valley*, edited by Nancy Newhall (5 Associates). Moderates a series of five films for television, *Photography, the Incisive Art*, directed by Robert Katz.

1960
Sierra Club publishes *Portfolio III, Yosemite Valley*, containing sixteen photographs. Makes the photograph *Moon and Half Dome*. Publishes *This is the American Earth*, text by Nancy Newhall (Sierra Club).

1961
Receives honorary Doctor of Fine Arts degree from the University of California, Berkeley.

1962
Builds a home and studio, designed by E. T. Spencer, overlooking the Pacific Ocean in Carmel Highlands, California. Over the next two decades, he produces in the spacious darkroom most of the fine prints made during his career. Publishes *Death Valley and the Creek Called Furnace*, text by Edwin Corle (Los Angeles: Ward Ritchie) and *These We Inherit; The Parklands of America* (Sierra Club).

1963
The Eloquent Light, a retrospective exhibition with prints from 1923 to 1963, shown at the de Young Museum. Receives John Muir Award. Sierra Club publishes *Portfolio IV, What Majestic Word*, with fifteen photographs. Publishes *Polaroid Land Photography Manual* (Morgan & Morgan) and first volume of a biography, *Ansel Adams: Volume 1, The Eloquent Light*, text by Nancy Newhall (Sierra Club). Subsequent volumes were not completed. Publishes revised edition of *Illustrated Guide to Yosemite Valley* (Sierra Club). Liliane De Cock becomes photographic assistant through 1971. Begins annual New Year's Day open house for his and Virginia's friends.

1964
Publishes *An Introduction to Hawaii*, text by Edward Joesting (5 Associates).

1965
Takes an active role in President Johnson's environmental task force, photographs published in the President's report, *A More Beautiful America . . .* (New York: American Conservation Association). Major exhibition, *Ansel*

Adams: The Redwood Empire, held at the San Francisco Museum of Modern Art, circulated a decade later by the California Historical Society.

1966
Elected a fellow of the American Academy of Arts and Sciences.

1967
Founder, President and, later, Chairman of the Board of Trustees, of The Friends of Photography, Carmel. Receives honorary Doctor of Humanities degree from Occidental College. Publishes *Fiat Lux: The University of California,* text by Nancy Newhall (New York: McGraw Hill).

1968
Makes the photograph *El Capitan, Winter, Sunrise.* Receives Conservation Service Award from the US Department of Interior.

1969
Delivers Alfred Stieglitz Memorial Lecture at Princeton University. Receives Progress Medal from the Photographic Society of America.

1970
Receives Chubb Fellowship from Yale University. Parasol Press publishes *Portfolio V,* with ten prints. Publishes *The Tetons and the Yellowstone,* text by Nancy Newhall (5 Associates) and revised edition of Basic Photo Series 1: *Camera and Lens* (Morgan & Morgan).

1971
Resigns position as a director of the Sierra Club. William A. Turnage hired and becomes his business manager until 1977.

1972
Exhibits retrospective *Recollected Moments,* at San Francisco Museum of Modern Art; show is sent by USIS to Europe and South America. Publishes a monograph, *Ansel Adams,* edited by Liliane De Cock (Morgan & Morgan). Best's Studio is renamed the Ansel Adams Gallery. Ted Orland becomes photographic assistant until 1974.

1973
Two exhibitions of Adams photographs organized and circulated by The Friends of Photography.

1974
First trip to Europe, where he teaches at the Arles, France, photography festival. Major exhibition, *Photographs by Ansel Adams,* initiated and circulated by the Metropolitan Museum of Art, later travels to Europe and Russia, through 1977. Receives honorary Doctor of Fine Arts degree from the University of Massachusetts at Amherst. Parasol Press publishes *Portfolio VI,* with ten prints. Publishes *Singular Images* (Morgan & Morgan) and *Images 1923–1974* (Boston: New York Graphic Society [NYGS]). Andrea Gray becomes executive assistant until 1980, and Alan Ross becomes photographic assistant until 1979.

1975
Stops taking individual print orders at the end of the year, but the 3,000 photographs ordered by December 31 take three years to print. Helps found the Center for Creative Photography at the University of Arizona, Tucson, where his archive is established. Receives honorary Doctor of Fine Arts degree from that university.

1976
Parasol Press publishes *Portfolio VII,* with twelve images. Meets President Ford at the White House to discuss environmental policy. Returns to Arles Photography Festival during second European trip and photographs in Scotland, Switzerland, and France. Elected Honorary Fellow of the Royal Photographic Society of Great Britain. Begins exclusive publishing agreement with New York Graphic Society, a division of Little, Brown and Company. Publishes *Photographs of the Southwest* (NYGS). Lectures in London, Tucson, Los Angeles, and San Diego. Major exhibition at the Victoria and Albert Museum, London.

1977
Publishes *The Portfolios of Ansel Adams* (NYGS) and facsimile reprint of the book *Taos Pueblo* (NYGS). With Virginia, endows curatorial fellowship at the Museum of Modern Art in honor of Beaumont and Nancy Newhall. Exhibition, *Photographs of the Southwest 1928–1968,* organized and circulated by the Center for Creative Photography. Begins complete revision of his technical books with the collaboration of Robert Baker.

1978
Publishes *Ansel Adams: 50 Years of Portraits,* by James

Alinder (Carmel: The Friends of Photography). Publishes *Polaroid Land Photography* (NYGS). Elected Honorary Vice President of the Sierra Club. Selected as an honorary member of the Moscow Committee of Graphic Artists, Photography Section.

1979

Dramatic increase in sales of Adams prints in public auctions and through photography dealers, leading to a significant expansion of interest in collecting fine-art photography. Adams prints account for some half of the total dollar value of photography sales in the United States during the year. Major retrospective exhibition, *Ansel Adams and the West,* held at the Museum of Modern Art. Subject of *Time* magazine cover story. Publishes *Yosemite and the Range of Light* (NYGS); eventual sales total more than 200,000 copies in hard- and softcover editions. Founding member and vice president of the Board of Trustees, the Big Sur Foundation. Lectures in Carmel, New York, San Francisco, Boston, Detroit, Cleveland, and Minneapolis. Begins writing his autobiography with Mary Alinder, who is employed as his executive assistant. John Sexton becomes photographic assistant through 1982.

1980

Receives the Presidential Medal of Freedom, the nation's highest civilian honor, from President Carter. Receives the first Ansel Adams Award for Conservation given by The Wilderness Society. Publishes The New Ansel Adams Photography Series Book 1, *The Camera* (NYGS). Exhibition, *Ansel Adams: Photographs of the American West,* organized by The Friends of Photography for the USICA and circulated through 1983 in India, the Middle East, and Africa.

1981

Receives honorary Doctor of Fine Arts degree from Harvard University. King Carl XVI Gustaf of Sweden presents him with second Hasselblad Gold Medal Award. Named Honored Photographer at the national meeting of the Society for Photographic Education. Holds final workshop in Yosemite, then transfers workshop location to the Carmel area under the administration of The Friends of Photography. Publishes Book 2 in his revised technical series, *The Negative* (NYGS) and three large posters, the first of a series (NYGS). Hour-long biographical film, *Ansel Adams: Photographer,* coproduced by

Andrea Gray and John Huszar for FilmAmerica. Mural-size print of *Moonrise, Hernandez, New Mexico* is sold for $71,500, a record high for a creative photograph.

1982

Celebrates eightieth birthday with a black-tie dinner sponsored by The Friends of Photography for more than 200 guests, during which he is presented the Decoration of Commander in the Order of the Arts and Letters, the highest cultural award given by the French government to a foreigner. Two exhibitions, *The Unknown Ansel Adams* and *The Eightieth Birthday Retrospective,* honor the event at The Friends Gallery and the Monterey Museum of Art, respectively. Pianist Vladimir Ashkenazy plays a concert for him in his Carmel Highlands home. Receives honorary Doctor of Fine Arts degree from Mills College. His 1936 Stieglitz gallery exhibition is recreated and circulated by the Center for Creative Photography as *Ansel Adams at An American Place.* Chris Rainier becomes photographic assistant until 1985.

1983

Publishes *Examples: The Making of 40 Photographs;* Book 3 of the technical series, *The Print;* three posters; and a 1984 calendar (all NYGS). Subject of an extensive interview in *Playboy* magazine. Meets with President Reagan on environmental concerns. Elected as an honorary member in the American Academy and Institute of Arts and Letters. Exhibition, *Ansel Adams: Photographer,* is organized by The Friends of Photography as a cultural exchange between the sister cities of San Francisco and Shanghai, China. Exhibition also travels to Beijing, Hong Kong, and Tokyo. Ansel Adams Day proclaimed by the California State Legislature.

1984

Dies April 22 of heart failure. Major stories appear on all major television networks and on the front page of most newspapers nationwide. A commemorative exhibition and memorial celebration are held in Carmel. California Senators Alan Cranston and Pete Wilson sponsor legislation to create an Ansel Adams Wilderness Area of more than 100,000 acres between Yosemite National Park and the John Muir Wilderness Area. Unanimously elected as an honoree of the International Photography Hall of Fame. Three posters and a calendar are published (NYGS). *Ansel Adams 1902–1984* published by The Friends of Photography.

1985

Mount Ansel Adams, a 11,760-foot peak located at the head of the Lyell Fork of the Merced River on the southeast boundary of Yosemite National Park, officially named on the first anniversary of his death. *Ansel Adams: An Autobiography* (with Mary Street Alinder) published in October (NYGS). The autobiography is enthusiastically received and reaches many best-seller lists, including number 7 on the *New York Times* list. Three posters and a calendar are also published. Exhibition, *Ansel Adams: Classic Images*, which drew some 6,000 viewers a day, shown at the National Gallery of Art, Washington, D.C.

Designed by Adrian Wilson

Production coordinated by Nancy Robins

Type set in Centaur and Arrighi by Mackenzie-Harris Corp., San Francisco

Paper: Centura Gloss by Consolidated

Printed by Gardner/Fulmer Lithograph, Buena Park, California

Bound by A. Horowitz & Sons, Fairfield, New Jersey